S.S.F. PUBLIC LIBRARY WEST ORANGE AVENUE

SSF

Painting Plant Portraits A step-by-step guide

Painting Plant Portraits A step-by-step guide

Keith West

Timber Press, Inc. *in association with* The Royal Botanic Gardens, Kew

> S.S.F. PUBLIC LIBRARY WEST ORANGE AVENUE

Copyright © 1991 Keith West Copyright under the Berne Convention

First published in Great Britain 1991 by The Herbert Press Ltd, London in association with The Royal Botanic Gardens, Kew

First published in North America in 1991 by Timber Press, Inc. The Haseltine Building 133 S.W. Second Avenue, Suite 450 Portland, Oregon 97204, U.S.A. 1-800-327-5680 (U.S.A. and Canada only)

Paperback edition published 1997, reprinted 1999

ISBN 0-88192-372-9

Designed by Pauline Harrison Set in Aldus Typeset by Nene Phototypesetters Ltd, Northampton, England Printed and bound in Hong Kong by South China Printing Co. (1988) Ltd

Library of Congress Cataloging-in-Publication Data

West, Keith R. Painting plant portraits : a step-by-step guide / Keith West. p. cm. Includes index. ISBN 0-88192-372-9 1. Botanical illustration—Technique. 2. Flowers in art. I. Title. QK98.24.W47 1997 751.42'2434—dc20 96-28308

CIP

Contents

	Introduction	7
	Glossary of botanical terms	9
1	Equipment and Materials	11
2	Techniques	13
3	General Notes	18
4	SNOWDROP, Galanthus nivalis	19
5	DAFFODIL, Narcissus cultivar	28
6	WINDFLOWER, Anemone blanda	34
7	IRIS, Iris sibirica cultivar	42
8	PINK, <i>Dianthus</i> cultivar	50
9	FIELD POPPY, Papaver rhoeas	56
10	SWEET PEA, Lathyrus odoratus cultivar	64
11	ROSE, <i>Rosa</i> 'Super Star'	70
12	HAREBELL, BLUEBELL, Campanula rotundifolia	78
13	SUNFLOWER, <i>Helianthus</i> cultivar	84
14	FUCHSIA cultivars	92
15	PERUVIAN LILY, Alstroemeria 'Sovereign'	102
	Index	112

Introduction

The portrayal of plants using the medium of transparent watercolour is an exciting adventure. Your productions will be attractive permanent records of favourite flowers. You will develop your artistic skills and find an enhanced appreciation of plant structure through the close attention needed in drawing.

The tradition of botanical painting dates back some 3000 years. Though sometimes created purely as decoration, realistic plant illustrations were widely used as pictorial aids in medicine and reproduced by woodcuts in early herbals. Later, for the requirements of botanical research, plant illustration developed under the hands of such superb artists as Georg Ehret, Pierre-Joseph Redouté and the brothers Franz and Ferdinand Bauer. Horticulture also provided an incentive in that the evolution of gardening as a recreation led to a broader enjoyment of plants and so enlarged possibilities for plant portraiture through enlightened patronage.

Today, botanical monographs, produced by institutions such as the Royal Botanic Gardens at Kew and Edinburgh and similar centres of study around the world, are usually illustrated by line drawings. These formalized black-and-white works are generally acknowledged as being better than photographs in revealing detail. Though botanical research is now less likely to call for the services of the plant watercolourist than in the past, botanical painting of the kind demonstrated in these pages continues to flourish. Books for the lay plant enthusiast often use fine watercolour illustrations and many galleries hold exhibitions entirely devoted to the field. There are hosts of practitioners maintaining the high standards of the past.

The models chosen for this book are from readily available species flowering through the seasons, from winter to early autumn. Starting at any point, you may continue step by step with twelve subjects through the year. Though it would be feasible simply to copy the plates through each stage, you will achieve more by collecting fresh material from the same species or closely related ones. You may then work by reference to the living plant while taking guidance from the book. By this means an original plant portrait will be created.

I have selected subjects without over-complex inflorescences or leaf shapes that might tax the beginner; but it has to be acknowledged that painting plants in the realistic tradition does require effort. It also needs patience, a methodical approach, and time. I have purposely not mentioned how long it has taken me to complete any of the plates as I am conscious that people work at different speeds – my pace, if recorded, might appear discouragingly fast to some and tortoise-slow to others. If you are not working professionally it is your own affair how long you spend at the drawing board. Even if you do expect to be rewarded, artistry is more important than time – within credible limits of course.

Should you only have short periods of time, you might select single elements of the subject: one stem rather than several, or perhaps a flower alone.

Most plants are from the garden and a few come from the wild. Rare or endangered species should not be collected – legitimate subjects abound.

Botanical knowledge is not assumed and so technical terms are kept to a minimum, though words such as 'anther' or 'ovary' are sometimes unavoidable – a short glossary appears opposite. Where technical words defined in the glossary first occur they appear in italics.

As this work is devoted to the use of transparent watercolour, the techniques used for opaque colours such as gouache (body-colour) are not covered.

If you are a beginner in watercolour please read chapters 1 and 2 before starting to paint your first plant portrait. The more experienced will find guidance in the particulars of plant painting in the body of the text. Career illustrators wishing to add further range to their work might also refer to my earlier book, *How to Draw Plants: the techniques of botanical illustration.*

To avoid repetition in every chapter, certain matters (for the beginner *and* the more experienced painter) are covered in the General Notes (p. 18).

Painting plants is an undertaking rich in satisfaction and the results will yield enjoyment for you and for others over many years. You will find that each plant you paint will be imprinted on your memory so that you will gradually build up a store of recollections and associations as you continually improve your skills.

Glossary of botanical terms used in the text

Where an example is given this does not imply that the feature described occurs only in the chosen plant.

Some terms have broader meanings than those given below. For clarity these definitions apply only to the usage in the text.

Anther The pollen-bearing part of a stamen: see fuchsia.

Bract A modified leaf, usually subtending an inflorescence and/or individual flowers: *see* Peruvian lily. Sometimes scarious (thin, dry, and more or less translucent): *see* snowdrop.

Calyx The outer floral whorl – the sepals collectively. Usually green: *see* harebell. Pl. *calyces*.

Capitulum A head-like inflorescence of small aggregated flowers: *see* sunflower. Cf. *ray-floret* and *disc-floret*. Pl. *capitula*.

Capsule A dehiscent (opening) dry fruit: see poppy.

Corona A trumpet-like extrusion originating between the petals and the stamens: *see* daffodil.

Cotyledon A leaf formed in the seed, the first to emerge.

Cultivar A variant of horticultural value or interest, persisting under cultivation.

Disc-floret An inner flower of a capitulum – as contrasted with a *ray-floret* (q.v.): *see* sunflower.

Fall An element of the outer floral whorl of an iris flower – often drooping: *see* iris.

Filament The stalk of a stamen: see fuchsia.

Irregular flower A flower divisible into matching halves along one plane only: *see* Peruvian lily. Cf. *regular flower*.

Keel a. united two lower petals of a pea-type flower: *see* sweet pea.

b. a ridge-like protuberance as in the keel of a boat: *see* Peruvian lily capsule.

Ovary The ovule (potential seed) bearing organ, which becomes a fruit on reaching maturity: *see* poppy.

Pedicel The stalk of an individual flower in a compound inflorescence: *see* fuchsia.

Perianth A collective term for the calyx and corolla, when they are not differentiated from one another.

Perianth-segment A division of the perianth.

Petaloid style-branch A petal-like element of a branched style: *see* iris. Cf. *style*.

Petiole Leaf-stalk.

Phyllary A bract, especially of the inflorescence of the Compositae family: *see* sunflower.

Ray-floret Outer flower of a capitulum – as contrasted with a *disc-floret* (q.v.): *see* sunflower.

Regular flower A radically symmetrical flower: *see* snowdrop. Cf. *irregular flower*.

Rhizome A horizontal, usually underground stem, which stores food: *see* windflower.

Sepal One of the separate parts of a calyx – usually green: *see* harebell. Sometimes petal-like: *see* daffodil.

Spathe-valves Bracts, often scarious, that subtend a flower – commonly enveloping it in bud: *see* iris. Cf. *bract.*

Stamen The male pollen-producing organ of a seed plant; typically composed of a *filament* and *anther* (q.v.): *see* fuchsia.

Standard The erect, upper petal of a pea-type flower.

Stigma Tissue receptive to pollen, usually found at or near the tip of the style: *see* fuchsia. Where the style is lacking, the stigmas are borne directly on the ovary: *see* poppy.

Stipule A leaf-like appendage, usually one of a pair, borne at the base of a *petiole* (q.v.): *see* rose.

Style Extension of tissue, arising from the top of the ovary and supporting the stigma: *see* fuchsia.

Wing A lateral petal of a pea-type flower: see sweet pea.

1 Equipment and Materials

WORK SPACE To assist concentration a separate room is useful, but failing this, space should be secured which best gives privacy.

LIGHTING The room or area for studio use should preferably have natural lighting without the admission of direct sunlight. Yet even in prime conditions you will need artificial light in the early mornings or evenings and not infrequently throughout winter days. Standard electric lights are biased towards the yellow to red end of the spectrum and so distort colours. Balanced fluorescent tubes yield close to natural light and blue-tinted 'daylight' bulbs are available – these are convenient as they can be used in the usual sockets. They give almost distortion-free light.

Lighting from the side should fall from the left if you are right-handed and from the right should you be left-handed.

Bear in mind that most completed paintings when on view will be seen for much of the time under ordinary electric light, which as well as enhancing yellows and reds drastically dulls blues. But this should not deter you from painting blue flowers, because they will always look well in natural light and in any case lights with a daylight-type spectrum may soon become commonplace.

WORKING SURFACE An inexpensive adjustable table-top drawing board may be used. This consists of a board supported by hinged brackets with struts that slot into notches to give different angles of slope. Alternatively, a perfectly acceptable surface may be created by tilting a drawing board (see below) against heavy books or the like on a steady table. The angle of slope is changed by moving the board backwards or forwards.

At the other extreme, a drawing-stand provides a plane which easily may be moved as required through all positions from the horizontal to the vertical. Graphic arts suppliers' catalogues show the large range available – from the most basic design, a simple adjustable surface on legs, to elaborate models incorporating drawers and inviting accessories.

SEAT A seat should be rock-steady, at an appropriate height and so comfortable that you are unaware of it. HAND-LENS This is a helpful tool in that by seeing exactly how plant parts fit together ambiguities in drawing may be avoided. Additionally, the beauty of minute details is revealed. An eight to ten diameter magnification is usual. The lens is often mistakenly held close to the object with the eye held back, so giving a tiny field of view. It is much better to put the lens to your eye and approach or raise the object until it is in crisp focus.

DIVIDERS OR RULER These are used to take dimensions directly from the model. I generally use dividers as they are easier to manipulate through foliage.

CRAFT-KNIFE OR SCALPEL Scalpels with disposable blades are excellent for use on plant tissues and lighter materials. A craft-knife is preferable for heavier work. If small children have access to the work area, scalpels must be kept out of reach. Craft-knives with retractable blades are safer.

FEATHER A stout feather is the best possible whisk for removing eraser crumbs.

WATERCOLOUR PAINTS come in tubes or pans. I find tube colours inconvenient and wasteful because leftover squeezed-out pigment is usually discarded. With pans all choices are to hand, one can move quickly from colour to colour pausing only to clean the brush.

Artists' quality watercolours are essential; it is a great mistake to buy inferior grades. Large wooden boxes containing all or much of a manufacturer's considerable range are vastly tempting and vastly expensive. Using watercolour on an almost daily basis I find that only seven hues are in constant use with a few others needed occasionally. These core colours are: lemon yellow, chrome yellow, Winsor red, alizarin crimson, rose madder, French ultramarine, Prussian blue. Permanent magenta and violet are rarely used but are useful as they are impossible to capture exactly by mixing. Various greens may be bought, but all I have used are less satisfactory than those derived from the mixes given in the text. Black is hardly used and I prefer the shadow colour (p. 13) laid down in several coats to give a vibrant effect instead of a manufactured

pigment. Of course in my paint-box I have other colours, collected over many years, but these have all fallen from favour through various faults.

I do keep one tube – white, in designer's concentrated colour; this is reserved for adding hairs to leaves etc.

The hues mentioned above are not a definitive selection – you could choose close equivalents. Apart from the qualification that a colour should fill a gap, the essential criteria are that hues should be more or less permanent and that they should be compatible with the others in your paint-box. Some pigments behave well when used on their own but are poor in combination with others. Unfortunately compatibility can only be determined when colours are actually mixed as it is then that washes may be found to dry in streaks or to be so unstable that an attempted second coat may lift the first layer.

BRUSHES should be of the first quality and Kolinsky sable is the best. Good brushes hold ample pigment, retain a fine point and are durable. Kolinsky sables fulfil all these requirements. Brushes of ox or squirrel hair or of synthetic fibre are not as satisfactory to a greater or lesser degree.

Sable brushes are expensive but to offset this it is possible to manage comfortably with only three grades. Two brushes of grades 0 or 1 are needed for fine detail: one of these should be kept for the use of white paint for hairs as this pigment tends to wear brushes more rapidly than others. A well-pointed brush of grade 3 or 4 is ideal for most other work (I also like to keep a fairly worn spare for blending edges etc. – see p. 16). For the paintings described in these pages the brushes mentioned will be adequate, but it is useful to have a bigger brush from grades 8 to 10 if you want to work on larger subjects.

Brushes should be kept clean and stored with their points intact and not touching the container sides. Prolonged contact may distort or separate the tips making restoration difficult. Should brushes be out of use for more than a few weeks it is sensible to keep them in a tube with a mothball.

PAPER is best bought by the sheet rather than in made-up pad form. This is more economical and it will make it easier for you to try a number of rag-based papers until you find some which feel right for you. Rough-textured paper should be avoided as it makes detail too difficult to capture; on the other hand smooth, hot-pressed paper has an unsatisfactorily slick surface. I find that the best grounds for botanical subjects are papers in the 'NOT' category (that is, they are not hot-pressed). These have a slight 'tooth' or texture which is agreeable, but the choice still is all too often between a surface that is fractionally too smooth and one that is just too rough.

Weight is also a factor; heavier grades, 140lb (per ream) and above, do not have to be stretched (p. 13) but this advantage is balanced by the greater cost of heavier types; also, stretching paper seems to make it slightly more responsive. Lighter papers must be stretched to prevent cockling, which otherwise happens when washes are laid down. Watercolour board is also available: this consists of a lighter-weight paper pre-stretched over a cardboard backing. Abraded surfaced and 'NOT' boards of this type are very good to work on, though expensive for everyday use.

PALETTES come in many styles – I like a porcelain variety which may be stacked.

WATER-JAR The perfect water container is glass, squat and capacious.

GUMMED BROWN-PAPER STRIP is used in stretching paper; the strip should be no narrower than 5 cm. Small rolls are much more expensive per metre length than those of around 17 cm diameter used by picture framers.

LIGHTWEIGHT DRAWING BOARD This is used as a vehicle for stretched paper; it is placed on top of the regular working surface or it may be used on its own. Plywood 5 mm thick is ideal cut to about A2 size, 65×47 cm.

PENCILS in grades HB, F, H and 2H provide sufficient variation in hardness for one or another to suit most paper surfaces. Whichever you use, it should be kept well sharpened to a fine point.

ERASER A white plastic type is recommended over gum or putty.

RAG OR PAPER TOWELLING is used for taking excess water from the brush each time it is rinsed.

PLANT CONTAINERS Various vases, jars, etc. may be needed according to the size of the model. I find florists' 'oasis' useful for many subjects – when placed in a saucer of water it makes a stable base.

Though the above list may seem lengthy, some items might be found or adapted from around your home. Three exceptions are brushes, colours and papers, which should all be of fine quality for satisfying results.

2 Techniques

DRAWING is the essential basis of any accomplished representational plant portrait. Though I think that even the most ham-fisted can improve with practice, you are blessed if you have a natural facility, because to draw plants accurately is quite demanding. While there are no magic shortcuts to success I have found the following hints do help.

Place your plant to best advantage with the flowers at eye-level or just below. Sometimes a painting is completed directly from material arranged in a container or 'oasis', but more often the work is composed by taking a single stem at a time.

Other than for very large specimens, plants are normally shown life-size, and this practice is followed throughout the book.

I usually start with a skeleton framework using light lines to indicate the likely position of each element. At this point the length of the stem or other longest component is taken with dividers or ruler and placed on the paper to ensure that it will fit easily in the space allotted. In taking this dimension the top is obviously the apex of the flowers or buds, the bottom may be defined by a leaf juncture or other convenient marker.

Sequences for drawing particular flowers are given with each subject as I do not think that it is feasible to offer here any useful generalization. Leaves are another matter: I always establish the midrib first, carefully following its curvature and angle to the stem. The margin is then lightly sketched in and the main veins shown before teeth or lobes are drawn.

At least a nodding acquaintance with the principles of perspective is a benefit but a good eye will compensate if you do not have this advantage. Strive to draw precisely what you see – modifying a little here and there for clarity: you might move a bud from behind a stem or twist a leaf so that more of its shape and surface is seen. But essentially the aim is to reveal the character of the plant in lifelike detail.

SHADING I don't care for this word but it serves as shorthand for the disposition of light and shade, conveyed exactly by the Italian word, *chiaroscuro*.

Shading wonderfully suggests form, though it should be used with restraint – more shadow can be added at any stage but the removal of over-dark pigment is tedious and difficult. Though the colours of shadows vary according to the light and their surrounds, a basic shadow mix may be made by using roughly equal parts of red and blue plus a lesser amount of yellow. These ingredients will give a neutral grey which may be made 'warmer' by a larger red component, and 'cooler' by using more blue. Though other hues may be used, from the list of colours on p. 11, I prefer alizarin crimson, French ultramarine and chrome yellow.

In the studies shown in this book, the modelling revealed by shadows is painted in directly after the pencil drawing in the sequence of steps. In looking at the shaded plates you will readily appreciate the importance of this phase – often such works would be acceptable as they stand.

Shadows, of course, also modify the tones of colours – the ranges of light and dark intrinsic to all hues.

To complete each painting following the shadow structure, the addition of colour is a relatively straightforward process, once the simple techniques outlined below are acquired.

STRETCHING Before concentrating upon the three basic ways of applying watercolour, I outline the technique of stretching in case you prefer to use the lighter weights of paper as I do. As noted above, stretching removes the likelihood of permanent cockling. Even when paper is stretched on the board, a ripple may occur when a large area of wash is applied, but on drying the paper will return to drum tightness. Cockling in a light unstretched paper cannot be removed.

Using a bath or sink, stretching will take only around a minute from wetting the paper. Cut the watercolour paper to fit with wide margins on the lightweight board. Cut gummed brown-paper strips to fit the sheet (fig. 1). Put a hand-towel to one side together with a well-moistened face-cloth, folded into a pad. Run enough water into the bath or sink to cover the paper.

1 Submerge the paper for around 30 seconds.

2 Remove the paper from the water and hold it up by one corner to allow it to drain briefly. Then, to place the sheet on the board, hold the paper by the

corners at one end (not diagonally). Allow the bottom edge to touch the board first and pull it into position as the rest of the sheet is gently laid down.

3 Cover the paper momentarily with the towel to absorb excess water. The towel may be dabbed lightly but without any rubbing as this would break up the paper surface. Removal of surplus water aids adhesion of the gummed strip but it must be done rapidly.

4 Immediately before being placed in position (fig. 1) each gummed paper strip in turn should have its sticky side moistened by one or two strokes from the damp face-cloth pad.

5 Finally, using your fingertips or thumb, make a fairly firm movement over each of the strips to remove any air bubbles.

While stretching, paper should lie flat so that drying will be even. Tilting, or accelerated drying by the use of a heater, will result in uneven pressures which may cause the paper to tear or to pull free.

Drying, which must be thorough, takes several hours – depending upon temperature and humidity. On an incompletely dry surface pencil points will score and erasure will be impossible as the paper will soil and fray. When convenient I stretch paper at the end of one day to be ready for the next.

Paper remains on the board until the painting is finished when it is cut free with a scalpel or craftknife. To preserve the surface of the underlying drawing board indefinitely, hold the scalpel blade almost parallel to the surface of the board and then insert it through the gummed strip at the edge of the paper underneath. Keeping the blade at the same angle, cut around the margin of the watercolour paper without marking the board. The paper with its edging of gummed strip can then be trimmed on a cutting board kept for this use, or this trimming can be done with scissors.

For the removal of the remaining gummed strip from the board, use a sponge (or the face-cloth pad) to soak the strip thoroughly with warm water; leave for a few minutes and then peel the lot away. Allow the board to dry before its next use.

Your hands should not be allowed to rest directly on the paper at any time. Dirt, sweat and body-oils have no place in a watercolour. I use a protective sheet of paper under my hand; this is also ideal for trying out colour mixes. It is appropriate to use an offcut of the watercolour sheet being worked on but almost any white paper will serve.

If you are a beginner with watercolour, before starting on the first plant subject, it would be as well to have a short practice with the three basic means of application: wash, gradated wash, and dry-brush.

If you decide to use a stretched piece of paper the following exercises will allow you to become familiar with the 'feel' of the taut surface, but provided that the areas covered are quite small, as suggested below, stretching is not necessary here. Remember to keep the protective sheet under your hand. I used the grade 3 brush throughout.

WASH The first step is to draw fifteen or so rectangles, freehand or ruled, of around 8×5 cm. Rectangles are convenient but any enclosed forms will be appropriate. Use definite boundaries as these will help you in learning control of the brush. Label the painted results to provide a reference (fig. 2).

The drawing board should be sloped to an angle of around 30 degrees to ease the wash in moving down under the brush.

In a palette mix a wash of any colour well diluted with water. It is best to use light tones to start with. Mix an ample amount to avoid running out.

1 Dip the brush in the wash so that the hairs absorb enough to swell the tip without risking drips (fig. $\mathfrak{Z}(a)$).

2 Apply the brush to the top corner of a rectangle and take it in one stroke to the opposite corner, holding it at a shallow angle so that the pigment band left behind is broad (b).

3 On completing the first stroke, make a second carrying the paint a fraction lower down and returning to the starting side (c). If the first stroke left enough pigment along its lower edge the second movement may be continued without lifting your brush from the paper. If the paint has not formed a

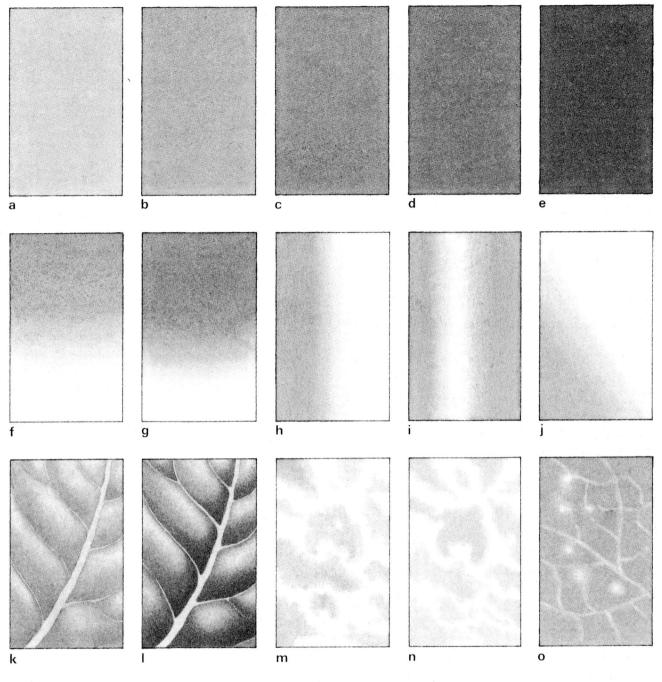

Fig. 2

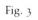

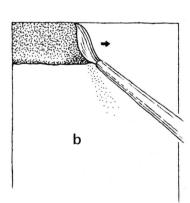

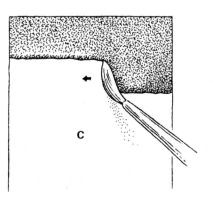

15

surplus, the brush should be reloaded. It will probably be necessary to reload for the third or fourth stroke.

4 Keep up this progress of back and forth strokes with a well-loaded brush to the bottom of the rectangle. Try to keep enough pigment on the brush to leave a reservoir at the bottom of each stroke throughout. On reaching the end dip your brush in the water-jar, squeeze it semi-dry on your paper towelling or rag and lift away any remaining accumulated surplus wash.

Your first attempt may dry with an even finish or it may be streaked. An imperfect result may be improved upon in the next rectangle if the area is first given a wash of clean water to improve absorption. This pre-treatment is often useful in painting delicate structures such as petals. Use this technique for a number of the panels until you feel at ease with it. After the wash has dried thoroughly, try a second layer on all the panels but one so that the difference can be seen between this and the rest. With successive layers continue to exclude one panel in sequence so that the first panel has one coat, the second two, the next three, and so on (fig. 2, (a)-(e)). Five or even six layers are possible, each deepening the tone and intensifying the colour. Eventually the paper will accept no more pigment and even though the surface may be perfectly dry, an attempt to add a further coat will only mar the earlier layers.

GRADATED WASH In watercolour one works from light to dark (light colours may not successfully be put over dark without using gouache or other media) but with this technique the usual is reversed in that you start with a pigment at any degree of density required and, by adding water in steps, work through a lightening tonal gradation (fig. 2, (f)-(j)). For the exercise use more of the rectangles and see that the water-jar contains clean water before starting.

1 Load the brush with the wash mixture as before.

2 Use the brush as with the wash technique, then, when reaching, say, halfway down, dip the brush-tip momentarily into water. This will dilute the pigment on the brush and also that on the lower edge of the previous stroke as the next stroke is made.

3 More water may be added with successive strokes or alternate ones, until clean water or the base of the panel is reached.

The tonal transition is speeded or retarded according to the amount of water added. Further coats will deepen the tone in the upper section, but remember that underlying layers must first be dry. To avoid delay, try the technique on several of the rectangles; by the time the third or fourth panel is complete the first may be dry enough to work on again.

DRY-BRUSH is another technique by which you may make a tonal gradation (fig. 2, (k) (l)). The term is misleading in that the brush is kept moist rather than actually dry. Dry-brush also permits the use of modifying colours, strengthening and shading without the speed needed for a wash. A disadvantage is that it does not give the same even finish as a wash and so the technique is used on small areas and where washes have earlier been laid down requiring added emphasis or detail.

Before starting this exercise add a wash to more rectangles and allow it to dry. Then continue as follows:

¹ Dip the brush into the wash mixture and when withdrawing it drag the hairs over the palette edge to leave them holding only a small amount of liquid. A few strokes on the practice sheet will indicate when the right degree of moistness is reached. Experimenting will soon show you how to judge this point.

² Apply the moist brush to imitate a leaf surface (k). Use short vertical strokes with a very light touch. The top of each stroke should blend in imperceptibly where less pigment is deposited.

3 After completing all the areas with the extra coat of pigment added by dry-brush, the sequence may be repeated again and again for the deeper tonal effect shown in (l).

Though dry-brush allows details to enhance broad washes, over use may give a laboured quality.

BLENDED EDGES AND CORRECTIONS You will find in working on plants that there are perhaps fewer sharp boundaries in colour or shadow than those which are blurred or softened. For this effect, in fairly large areas a gradated wash may be used, but in small organs, such as many petals, a swift transition is best gained by lifting off still wet pigment with a clean moist brush-tip. If done judiciously, with your brush-tip retaining just the right amount of moisture, edges may be blurred in a controlled way (*m*). Highlights may also be lifted out of a wash by this method. I keep a spare brush in my free hand more or less throughout each painting as it is often needed.

Blurring or blending from a still wet wash is highly successful, but once pigment has begun to

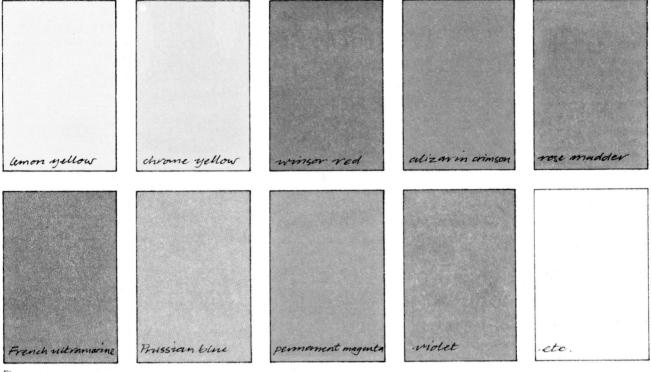

Fig. 4

dry significantly it becomes much less easy to manage. You should then wait until the surface is perfectly dry before a clean moist brush-tip is used to gently rub and absorb pigment. Washing out the brush often, the process should be repeated until no more colour comes away or until the paper surface begins to break up. You will notice that blending in edges in this way is not as effective as when the paint is still wet (*n*). By shaping the brush-tip into a chisel form, dried pigment may similarly be rubbed away to suggest leaf veins and similar structures (*o*).

A clean moist brush-tip is also the means of correcting errors in both wet and dry pigment by the process described above. In taking out unwanted colour, perhaps after overrunning a pencil line, be careful that the paint is not too wet or your brush too moist, as then the colour will tend to flow back into the cleared area. Dried pigment may be removed reasonably well from small patches, though usually a faint trace remains. Pigment left behind is much more noticeable on larger areas – the strategy then is to introduce covering foliage etc. Do not try to eliminate mistakes by the use of white paint as it will stand out jarringly against the off-white of watercolour paper.

After these exercises you might also care to experiment by adding one to several colours to a wet ground; or see what happens when you try to add pigment to a wash area that is only semi-dry – in most instances paint is lifted off rather than applied.

Do make the kind of chart shown above (fig. 4). I have one, mounted on card, which serves as a handy reference for all the colours in my paint-box. Follow the order of the paints in your container. For some colours two coats may be necessary, for others one layer will be enough. It is worthwhile to label panels and to reserve several for later acquisitions.

3 General Notes

The following notes apply for all the subjects.

When plants are placed in 'oasis' it is understood that this useful florists' accessory has first been placed in a saucer containing water.

Flowers are placed at eye-level or just below and of course arranged to show the details of their structure as well as their beauty.

You will find that with 'NOT' (not hot-pressed) watercolour paper, the back of the sheet often presents a more agreeable surface – this was used for all the plates in the book.

Normally I use a 2H pencil for drawing plants; this is used very lightly and rubbed down as the work progresses so that finally it is more or less invisible. In creating plates for this book the first three, snowdrop, daffodil and windflower, were drawn with a 2H. I then adopted an F for better reproduction. I recommend, however, that you stick to a 2H for most surfaces.

When beginning to draw I find that it helps to sketch in a skeleton framework of just a few lines to indicate the positions of stems etc. This preliminary was used and noted in making most of the plates. These lines were erased as the work progressed.

Except where another brush grade is mentioned, I used a number 3 brush.

Some washes will be used several times while painting a plate, and I find it helpful to label their palettes by writing on strips of masking tape.

The same basic mix was used for shading throughout; details are on p. 13.

In most colour combinations I have used no more than three hues. The major component is given first – though often they are more or less equal in amount.

The procedure of blurring and softening edges with a clean moist brush-tip as described on p. 16 is used throughout – you will be able to see by the illustrations where this simple technique is called for.

Translucence is a feature seen in organs that are thin enough and of a density to allow the passage of light to a greater or lesser extent. In petals like those of the poppy, translucence gives a brilliance that is far beyond the capacity of paint and paper to record – but often the more muted translucence seen in leaves can be captured, as discussed in the text. Leaves should be positioned so that their local colour predominates, but one or two patches of translucence will provide pleasing accents.

The sequence of steps seems to me to be logical and appropriate, but please don't think that this should be taken as a rigid format – do evolve your own solutions as you gain experience.

4 SNOWDROP, Galanthus nivalis Family Amaryllidaceae

In the Victorians' fanciful language of flowers the snowdrop symbolized Hope. When the newly emerged flowers are seen on a dreary mid-winter's day the epithet seems appropriate. Together with a handful of other species, snowdrops signal the beginning of a new flowering season.

The snowdrop, also known in the past as Candlemas bells and February fair maids, is doubtfully native in Britain though present in many woodlands. It is also cultivated widely. Found through much of Europe as a wild plant it is a garden subject in other temperate parts of the world. A number of cultivars are named, including a common, though to me incongruous, double form. A few other species of this small genus are occasionally seen.

Though fragile in appearance, the nodding flowers survive biting frosts and buffeting gales. Sensitive to light the petals close at night and in dull weather, to open widely again under bright skies. This feature is especially evident when plants are brought indoors – to catch the 'bell' phase you have to work quickly.

Snowdrops have a faint fresh fragrance. In a warm room, working with the flowers to hand, you may catch the subtle perfume.

The snowdrop painting appears complex but don't be deterred from tackling a similar setting. In ana-

lysing the work you will see that the individual components are all simple in form and the various steps to completion are not difficult. But compositions such as this are time-consuming even if proportionately rewarding. Once the preliminary drawing is done it is feasible to break the sequence at any point: fresh flowers may be used when following on.

The rest of the subjects in this book are shown against white backgrounds because coloured flowers are often best appreciated when removed from distracting surrounds. A different treatment is called for with white or very light-coloured flowers as they may be lost on a white backing. Sometimes it is appropriate to contrast white blooms against foliage, especially if the plant concerned has largish leaves. Another ploy is to tint or lightly shade the area behind such flowers with the dry-brush technique leaving a softened faded-out edge in vignette style.

For the snowdrops I thought that a typical winter setting would be evocative, forming in this instance an addition to rather than a subtraction from the topic, with the background showing off the flowers to best effect.

Paper: stretched Arches 90lb NOT. Image area $225 \times 160 \text{ mm}$.

1. DRAWING [A]

To provide the snowdrops' background I gathered oak and beech leaves, moss, pebbles, and a prunedoff twig of apple tree, as well as an eroded snail shell, a fragment of tile and one of many small pieces of decorated china. Some soil was skimmed off the garden surface with a trowel and placed on a plate for reference.

Half a dozen snowdrops were cut below the points at which they emerged from the ground and inserted into 'oasis'.

Next, with dividers, the height of the snowdrops was measured and by transferring this span to the paper and moving the instrument up and down I was able to assess the best positioning for the two groups of flowers.

Very lightly, the main elements were indicated in skeletal form with lines showing the height of each group of snowdrops and the measured length of the foreground oak leaf. The drawing was created around this framework.

The first snowdrop to be detailed was the one still in the 'bell' phase at the upper left in the top clump. The rest of the plants in this group were then added by turning the 'oasis' to gain the best position for each one.

The springy fine stems of the flowers

were interesting. These wiry structures, curved to hold the flowers in their nodding position, are strong enough to whip back and forth in high winds without damage. The callus-like tips to the leaves are another unusual feature – these may assist in the plants' emergence from frost-hardened soil.

The oak leaf was then drawn in towards lower mid-left, providing a strong diagonal echoing some lines in the leaves of the snowdrops. In developing the composition I had in mind a roughly circular movement through the oak leaves etc. which would nicely counter the solid verticals of the grouped flowers. In drawing the oak leaf the midrib was done first and other major veins were added as the leaf outline was established. The tracery of minor veins was left to be suggested later with the brush.

On its own the oak leaf looked too isolated and too powerful in form, so to lessen this effect a beech leaf was added on the left running out of the image area. Also, the oak-leaf outline was broken, after a sortie into the garden, by adding the *cotyledons* of newly emerged seedlings at lower left – a further reminder of the beginning of new life. Some fresh snowdrops were collected and placed in the 'oasis' alongside the first ones. The lower group of snowdrops was then drawn.

Another oak leaf was placed partly behind the lower group of snowdrops to 'turn' the subjective line projected by the first leaf. These two leaves seen together formed almost a 'V' shape. This appeared rather too dominant so a small mossy stone was added at the bottom right to blunt the suggested acute angle. A further oak leaf was drawn at the top left extending behind the upper group of flowers and continuing the circular move-

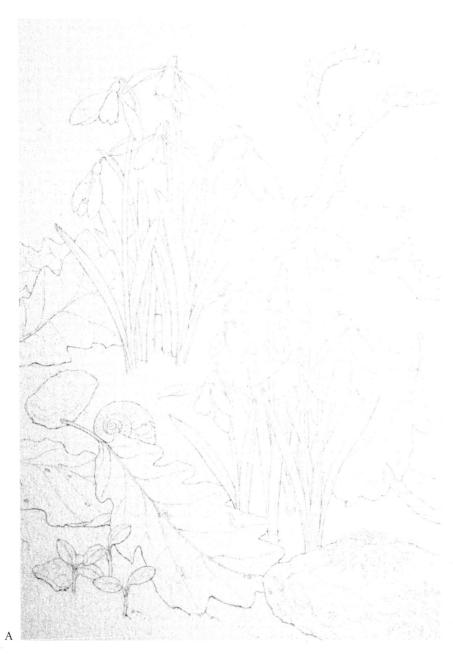

ment of the composition. The apple twig was then brought in at the top right and more leaves were placed to form an uneven horizon against the sky.

Oddments from the garden were placed to enliven the soil area: the eroded snail shell is at mid-left, a piece of ancient tile lies just above the mossy stone and the china fragment was placed at the bottom left. The china pattern was in a blue that I thought might receive a pale echo in the sky. A pebble was inserted above the snail shell and a pebble-like piece of mortar was shown protruding from under an oak leaf at the top right.

Any long-inhabited spot will yield similar artefacts to those mentioned above, as well as many natural bits and pieces worth including – though you need to be careful not to put in items that will take attention from the main theme.

At this stage the soil surface was left blank as I thought that the more or less random detail would be better brushed in later.

2. SHADING [B]

The tone of the soil was important to establish first as, together with the sky, it forms the main background. The shadow mix (p. 13) was applied in fairly dilute form. It was put on in small easily managed patches, loading the brush lightly. A true wash would not have been controllable around such tricky detail and in any case an even surface was not needed for the broken soil. The edges of each patch of pigment were blurred while still wet.

After the first coat on the soil the sky was painted as the other major component. I wanted to add some blue breaks in the cloud later and these openings allowed me to partition the sky into discrete areas that would be possible to handle using an even wash. The sky colour was made from the shadow mix with added chrome yellow to give a more or less neutral grey. After dilution the wash was

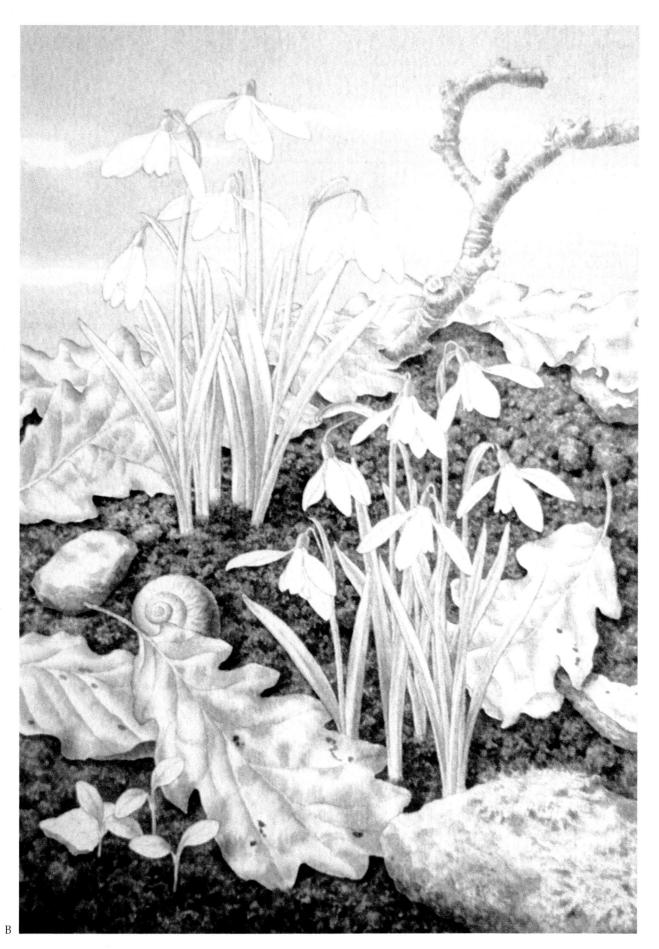

applied to each cloud area blurring out the edges while they were still damp (as with the soil patches). The most difficult part was to manipulate the wash-laden brush around the flowers. Inevitably some pigment found its way on to petals etc. but this was removed before it dried.

The shadow mix used for the soil was then diluted a little and added to the oak leaves, stones etc. and to the snowdrops – apart from their petals, which were left until later.

A second coat of shading was added to the soil using dry-brush. The soil was composed of minute coagulated granules which in turn formed various sized particles and lumps; these were portrayed by using short dabbing strokes. A third coat was added in places to strengthen shadows and to enhance the effect of a fragmented surface.

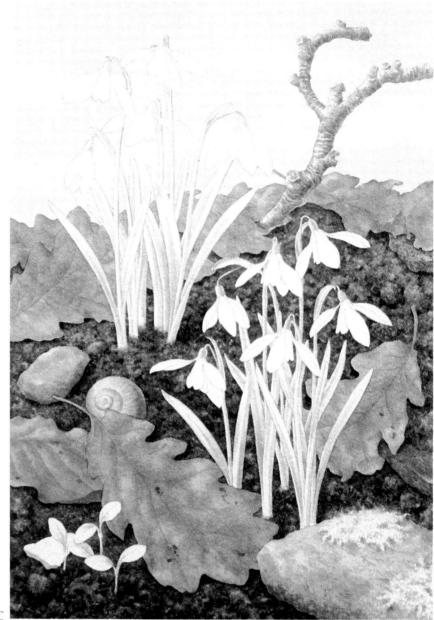

3. FIRST COLOURS – MAINLY BROWNS [C]

Though the shadow mix used for the soil was coincidentally close to the local colour, the addition of French ultramarine was needed to give a sepia richness. Pigment was lifted out in some places to provide dull highlights.

A grey close to that used for the sky, though slightly more intense, was used for the apple twig.

The brown of the oak leaves was then simulated in a mix composed of chrome yellow and alizarin crimson with a little French ultramarine. A

first wash was applied lifting out lighter areas while the pigment was still wet. Touches of this colour were also used for parts of the twig.

The beech leaf at centre left was rather more coppery than the oak leaves. It was painted with some of the oak-leaf mix poured into another palette and enriched with extra alizarin crimson.

The snail shell began to look too prominent. As its underlying colour was the same grey as that used for the sky this mix was used to lessen contrast.

The sepia was diluted for the pebble at mid-left and the piece of mortar at top right. When the latter had dried, texture was introduced with drybrush.

A first coat of reddish brown for the tile shard was derived from alizarin crimson and chrome yellow modified with French ultramarine.

To balance the background material the stone in the foreground on the right was washed over with a very dilute parchment-coloured blend from the twig and oak-leaf mixes in virtually equal parts. The moss patches were skirted and their edges softened.

4. FIRST GREEN COAT [D]

The yellowish green of the moss was mixed from chrome yellow and Prussian blue dulled by a brush-tip of alizarin crimson. This was applied with a dryish brush.

For the green parts of the snowdrops, excepting the petal markings, the moss mix was used with a touch more Prussian blue. In progress, and while the paint was still moist, colour was lifted off the lower sections of the sheathing *bracts* and also from leaf tips and bases. Faint touches of the same green were dry-brushed on to the twig and used for a first coat on the cotyledon leaves at bottom left.

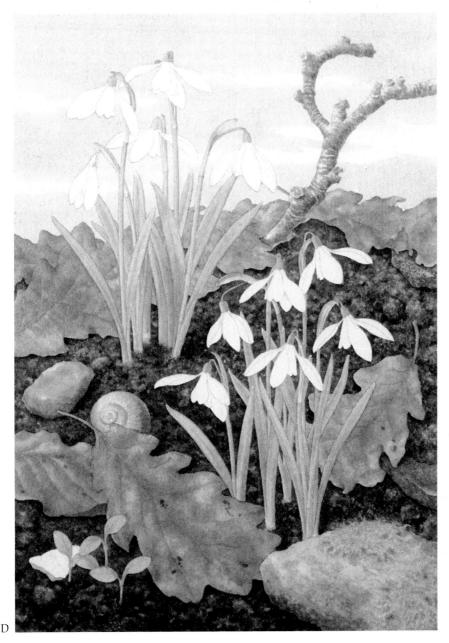

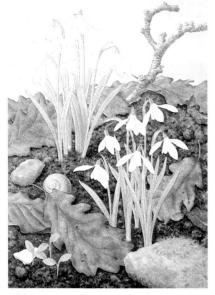

5. SECOND BROWN COAT [E]

The colour of the oak leaves was intensified in places by dry-brushing on a second coat. By this means the modelling of the leaves was also reinforced. A grade 'o' brush was then used with the same colour mix to suggest the delicate reticulation of minor veins.

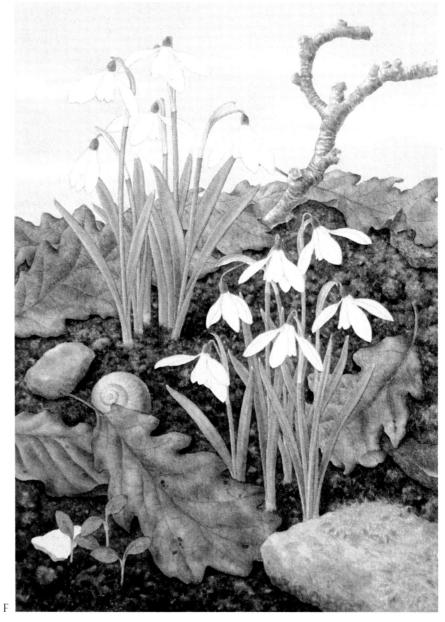

6. SECOND GREEN COAT [F]

More green was dry-brushed onto the snowdrops' leaves and *ovaries* after a little extra Prussian blue was added to the mix. Chrome yellow was then added again to modify the green for further colour on the cotyledon leaves.

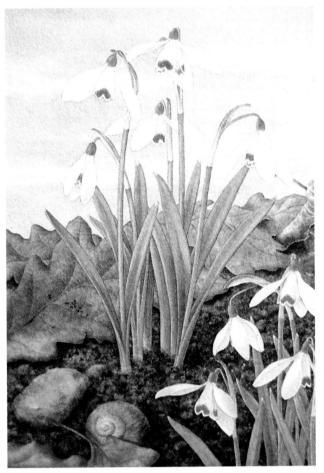

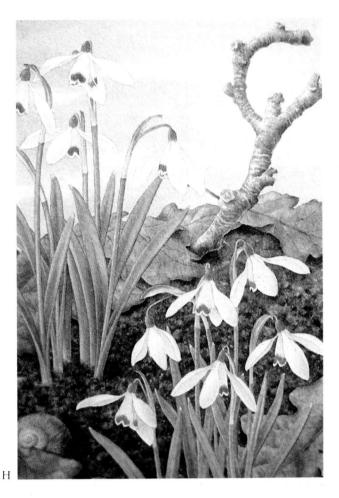

G

7. FINAL STAGE [G, H, I, J, K]

Many small touches and adjustments were needed to finish the work.

The characteristic green markings on the inner petals were done with a grade 'o' brush using a fresh mix from chrome yellow, Prussian blue and a hint of alizarin crimson. The same green was used to add to the pigmented parts of the bracts. After adding more Prussian blue to this green the leaves of the snowdrops were deepened here and there. A dilute wash of pale blue – French ultramarine and Prussian blue in approximately equal amounts – was used for the gaps in the cloud. The colour stopped short of the cloud margins and the edges were softened to leave a 'silver lining'.

More French ultramarine was added to the above blue to paint the patterning on the chip of china.

I felt that the moss green should be darkened in places so a new mix was

made to do this while at the same time indicating the minute fronds more clearly.

With a much diluted shadow mix the snowdrops' petals were given judicious touches. The brush was lightly loaded and no hard edges were allowed to remain. The aim was to suggest the modelling of the petals without significantly reducing their contrast with the background.

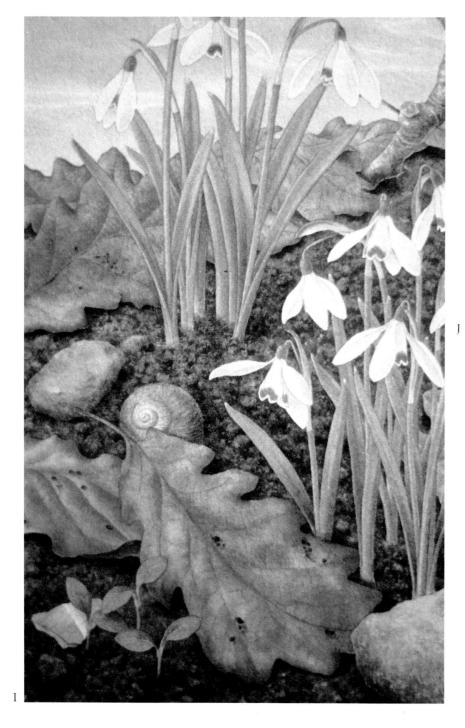

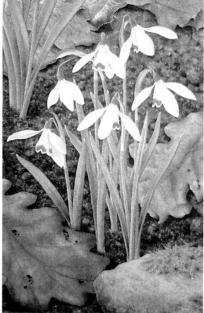

Pencil lines around the petals appeared needlessly obvious and these were erased to leave the merest trace. Then the cloud colour was diluted and gently dry-brushed where required to increase the tonal difference between clouds and flowers. The sky was also deepened at top left.

The snail shell was worked over with twig grey to show the irregular markings; moss green and china blue were also dry-brushed on. The same blue was drifted onto the leaf at the left of the lower snowdrops to suggest bloom. Cotyledon stems were coloured with alizarin crimson modified with French ultramarine.

The last adjustments were made using the shadow mix in several places – mainly to the soil surface, the oak leaves and the stone at the bottom right.

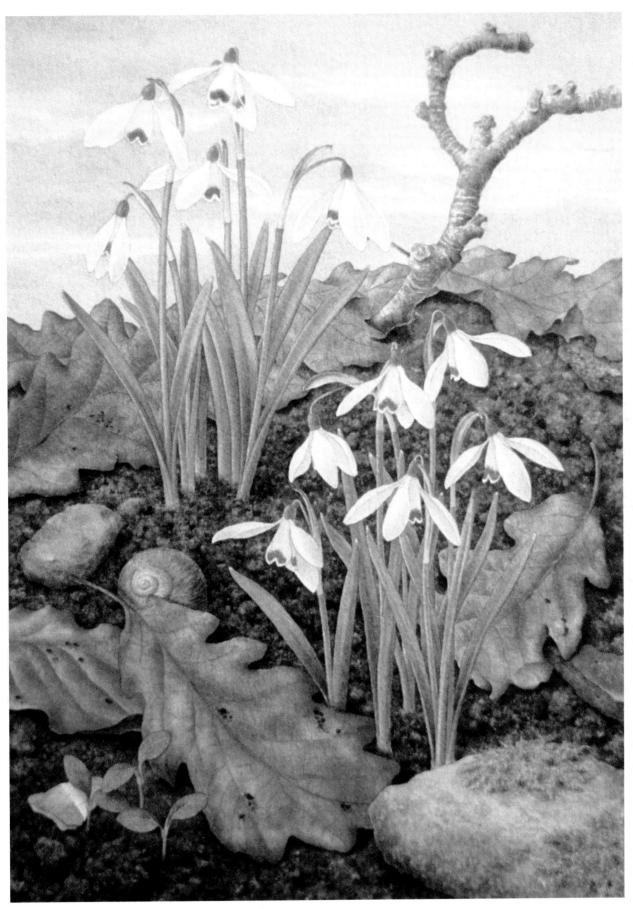

K. Snowdrop, Galanthus nivalis cultivar, garden, February 1990.

5 DAFFODIL, *Narcissus* cultivar Family Amaryllidaceae

Drifts of daffodils are a powerful floral symbol of spring. At their best in the spacious setting of the surrounds of a stately home, they just as strongly announce the arrival of the new season in my own garden.

The generic name is that of the Greek youth Narcissus (Narkissos) who fell in love with his own reflection in a pool. Unable to embrace the perfection he saw, he wasted away until the pitying gods transmuted his form to that of the flower.

Curiously, 'daffodil' also has a Greek root – in earlier English the flower was known as 'affodil', derived through Latin *affodilus* from Greek *asphodelos*, the asphodel (lily).

The shape of the flower is composed from three elements: an outer whorl of three petal-like *sepals* (*calyx*-segments); an inner whorl of three petals (together these two whorls form the *perianth*); and a

trumpet-shaped *corona*. The ellipses of the 'trumpets' need care in drawing as do the frilled edges of the coronas.

Having been cultivated for centuries it is not surprising that from some sixty species there are now about 6000 named *cultivars*. I have illustrated a familiar type, but a selection could have been made from such oddities as *N. cyclamineus* which resembles a tiny Christmas cracker, or *N. bulbocodium*, aptly known as the 'hoop petticoat'.

Myriads of daffodils appear in the shops before the worst of winter. These might be thought to devalue the currency of the locally-grown flowers before spring arrives, yet in dark December their golden glow is very welcome.

Paper: stretched Arches 90lb NOT. Image area: 330×195 mm.

1. DRAWING [A]

After experimenting with a lightly sketched layout I decided to show three flowers and a swelling bud. I placed these in a glass container with a narrowish neck.

I drew the lowest flower in the composition first. The ellipse of the 'trumpet' corona was sketched in using dividers to measure off the diameter. The detail of the frilled edge was then filled in carefully. Then the *perianth-segments* were drawn: the first roughed in was the upper one (from the petaloid calyx) and the others followed before the finished line was added. Only the beginning of the flower-stalk was shown at this stage.

The flower at the top right was drawn in the same way – after its position was established by starting with the flower-stalk emerging from behind the first bloom.

Next came the flower at top left, again starting with the stalk.

The leaves encircling the central

A

flower's stem followed: first the right leaf, then the central one and the leaf to the left. The outline of the upper part of this last leaf was only lightly

suggested until the bud was placed. The tightly furled flower-bud, just emerging from its enclosing *spathevalve* (the translucent brownish covering), was the final component of the composition.

2. SHADING [B]

A key element in this work was the low-contrast tonal difference between the daffodil perianth-segments and the white paper. I decided to establish this first in detailing the flowers. I used the shadow mix (p. 13), welldiluted, softening all edges. To maintain the light impression of the flowers I was careful not to over-darken any part.

Deeper tone was built up on the leaves and stems. As this progressed I found that, in drawing, the completion of the right flower-stem had been missed – this was added and washed in. The shadow was further diluted to keep the stalk in the background.

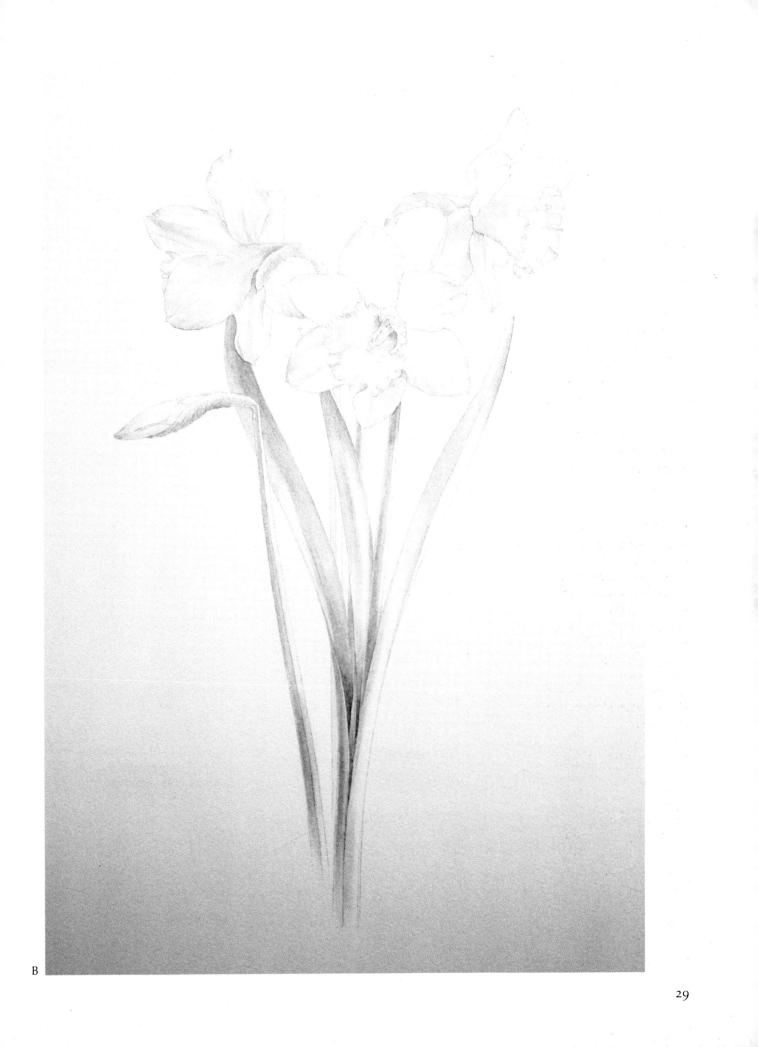

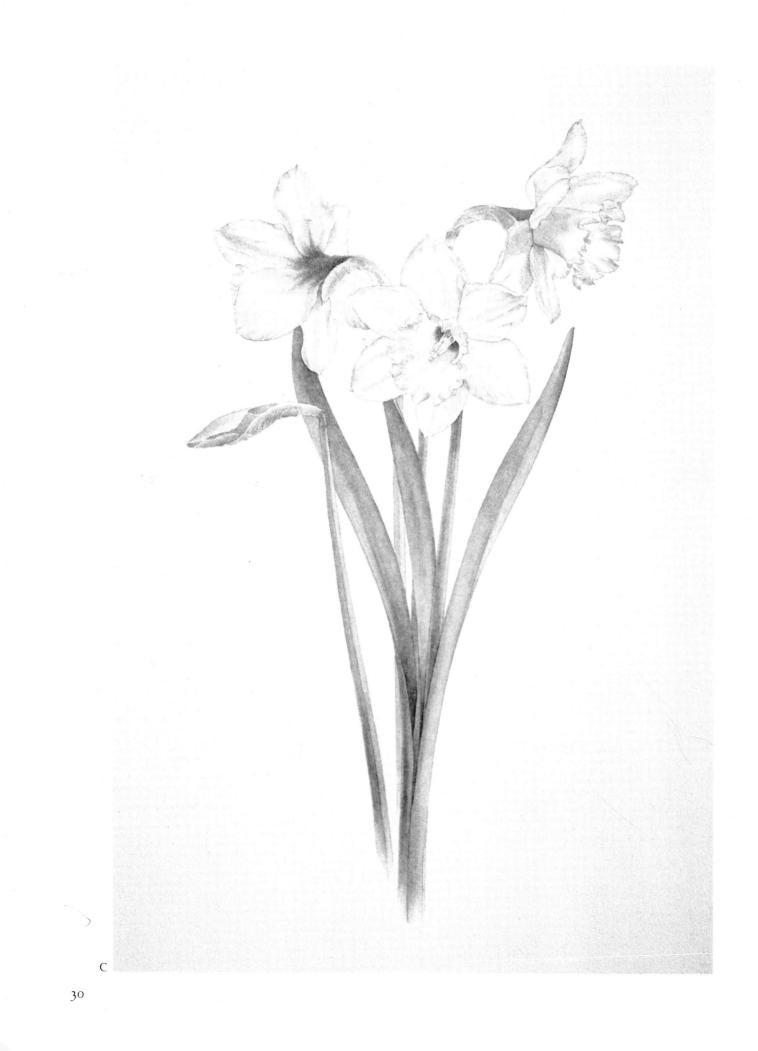

3. FIRST GREEN COATS [C]

A yellow-green was made from chrome yellow, Prussian blue, and a touch of alizarin crimson. This wash was used on parts of the leaf blades as well as on their bases, on the flower bases and on the bud.

More Prussian blue was added to the above mix for the basic blue-green of the body of the leaves. In progress, the wash was steered around the yellow-green parts of the blades of the leaves and gently blended into the yellow-green of the leaf bases.

D

4. FLOWER YELLOWS [D, E]

A weak wash of lemon yellow was used for the perianth-segment colour. After it had dried the hue was made more intense in some shadow areas by the addition of a drybrushed second coat.

For the brighter yellow of the coronas, chrome yellow with a little lemon yellow was mixed. Again on drying, extra pigment was drybrushed mainly into shadows.

31

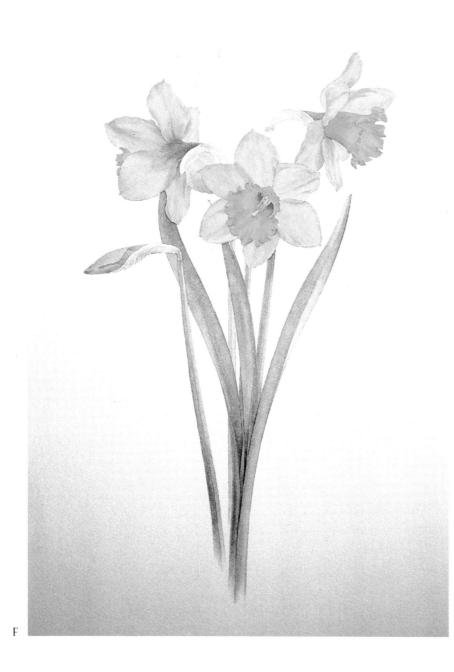

5. SECOND GREEN COAT [F]

The blue-green wash of the leaves was used to deepen their colour where required – lighter parts being skirted and blended in.

6. FINAL DETAILS [G]

The spathe-valves were painted a pale brown from French ultramarine, chrome yellow and alizarin crimson. After the first very dilute wash had dried, the valves were detailed by a slightly more intense mixture of the same colour; the parallel veins were suggested with a grade 'o' brush-tip.

More blue-green was applied to the leaves and stems where needed. The same colour was used with a grade 'o' brush to indicate the parallel venation of leaves and stems.

The yellow-green of step 3 was needed for the slight translucence seen on the left and central leaves. The mix had dried and only a little water was added before the colour was dry-brushed into these brighter parts.

Lastly, shadows on the bud and about the enfolding leaf bases were dark-ened.

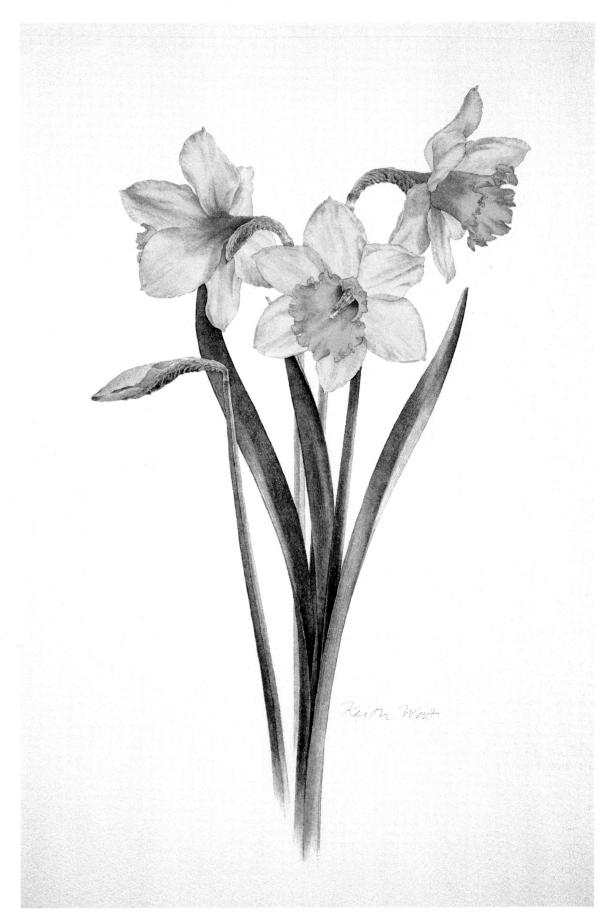

G. Daffodil, Narcissus cultivar, garden, March 1990.

6 WINDFLOWER, Anemone blanda Family Ranunculaceae

Blue windflowers carpet the Greek hills from February to April. Though in cultivation this blue form may predominate, mauve, pink, and white flowers are often seen.

The generic name is Greek and it means 'windflower'. Webster's dictionary contends that the name refers to the flowers being easily stripped by the wind. This origin seems unlikely, because while we had tiles torn from our roof, windflower petals were not noticeably affected. I prefer to think that the Greeks fancied that the flowers were born of the winds.

Several plants from this genus are especially good to paint: I have done versions of the Japanese anemone, Anemone \times hybrida (syn. A. japonica), and every couple of years or so I paint our modest wood anemone, A. nemorosa. The intense colours of A. coronaria also make it a popular subject.

In *regular* flowers (see also p. 84) I find it helpful to draw first the central, sexual, portion. Then a convenient starting petal is chosen, usually at the top. The other petals are then roughed in alternately, to left and right of the first, until the circle is completed. By this method you are less likely to end with too little or too much space for the final petal than if you work your way around in one direction only. Another method is first to put in petals at more or less cardinal points.

An odd feature of the Ranunculaceae family (as in the present subject) is that petal numbers and dimensions may differ widely within a population. In Britain this is especially noticeable in the early flowering lesser celandine, *Ranunculus ficaria*.

Paper: stretched Whatman 90lb NOT – watermarked 1946. Image area: 245 × 160 mm.

The paper used for this plate was the last of a few sheets which I inherited. It has the best handling qualities of perhaps any paper that I have used – certainly superior to those so far worked on of modern manufacture.

1. DRAWING [A, B]

On bringing windflowers indoors I soon found that they presented a small problem. In the warm dry studio they reacted by opening their flowers wider than those seen outside. The solution was to collect individual flowers, work on them as quickly as I could, and use fresh blooms for further detail. The stems were placed in 'oasis'.

The opening flower on the left was drawn very quickly, taking dimensions with dividers and sketching in the petals before fining up. This was succeeded by the upper flower and the smaller flower at the upper right – both established in the same way.

A flower in bud was inserted at the lower left – partly to improve balance and also to give a more complete sequence.

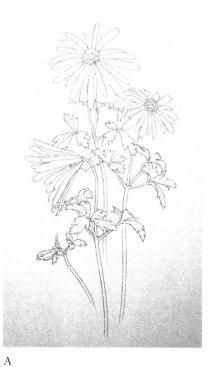

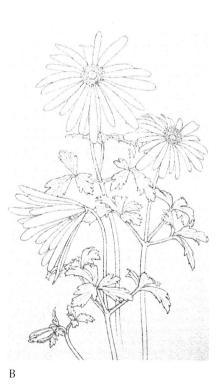

At this stage I had not made up my mind about using a *rhizome*; the possibility was mulled as the painting developed.

Then in more relaxed fashion the stems and leaves were drawn, detailing the leaflets with care. I noted that the stems thickened below their juncture with the leaflets.

2. SHADING [C]

The shadow mix (p. 13) was first used on the leaflets where they curved down to meet the stems which in turn were painted. Fresh flowers were brought in to replace the earlier blooms which had by then opened with their petals fully reflexed. A second coat was dry-brushed into the darkest areas.

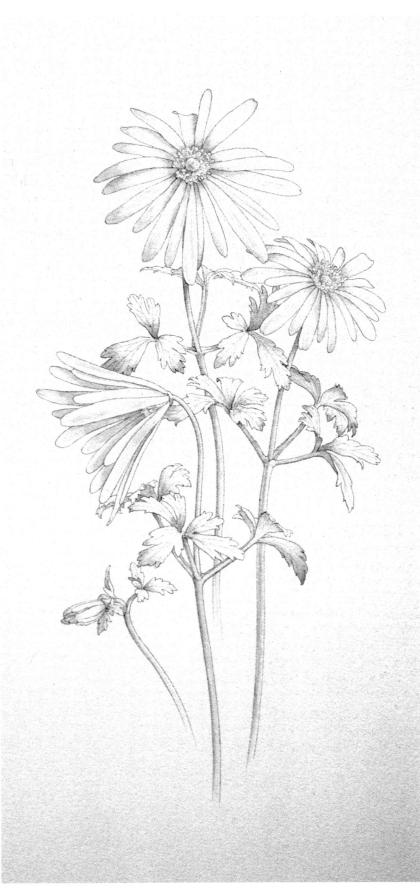

3. FIRST GREEN COAT [D]

A pale fresh green wash was mixed from chrome yellow and Prussian blue. This was used on the ovaries (at the flower centres) and as an underlying colour for all the vegetative parts.

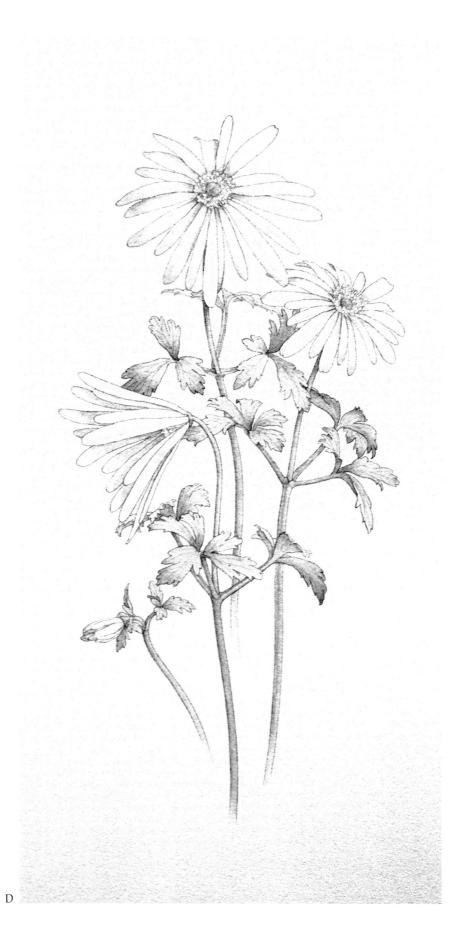

4. FIRST PETAL COAT [E]

I used a dilute wash of French ultramarine and violet for the petals. Moderately bright highlights were lifted out while the pigment was still damp.

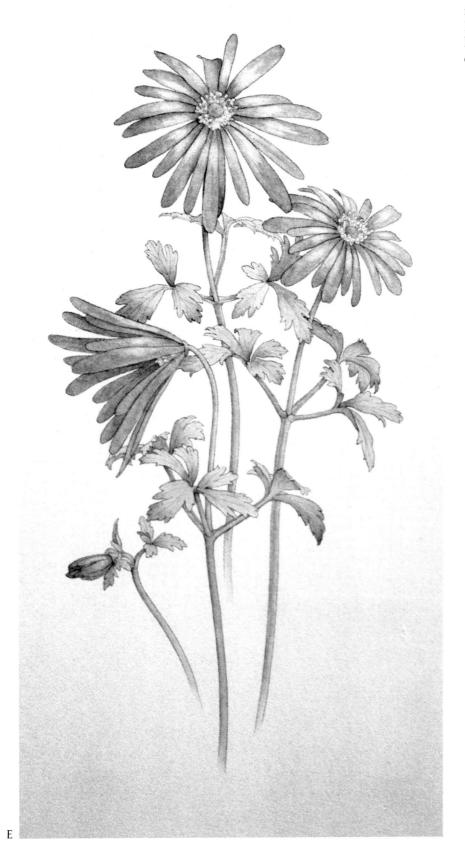

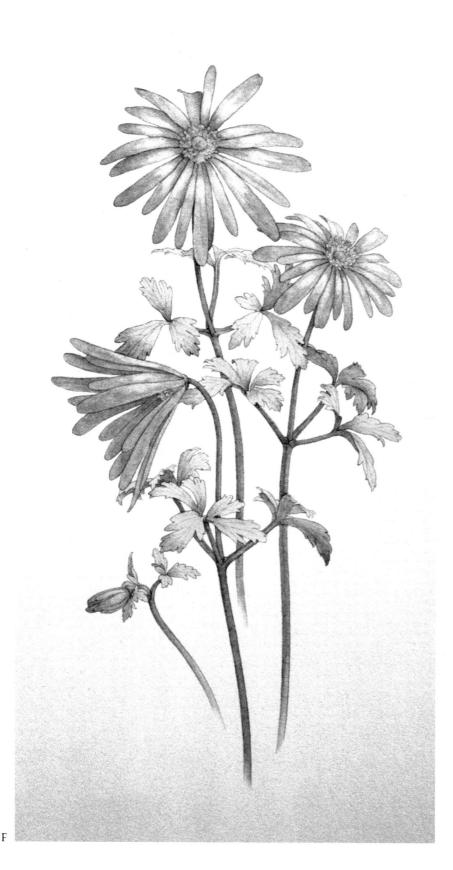

5. YELLOW AND RED [F]

Light lemon yellow was dry-brushed onto the *stamens*. The green stems were modified by a wash of alizarin crimson dulled by French ultramarine.

6. SECOND COATS OF GREEN AND BLUE-VIOLET [G]

I added some of the original green to the bases of the petals on both the opening flower and the bud. The green of the ovaries was also strengthened. To this same wash more Prussian blue and alizarin crimson was added to heighten the colour of the leaves – dry-brush was used to control coverage so that the lighter coloured veins remained visible.

The petal colour was deepened from the original blue-violet mix, again using dry-brush. Speckling was recorded on the backs of the wider petals of the opening flower.

7. FINAL TOUCHES [H]

The red mix for the stems was used again for enrichment in places. Though present throughout, hairs were most dense on the upper portions of the flower stalks; they were shown with a very sharp 2H pencil.

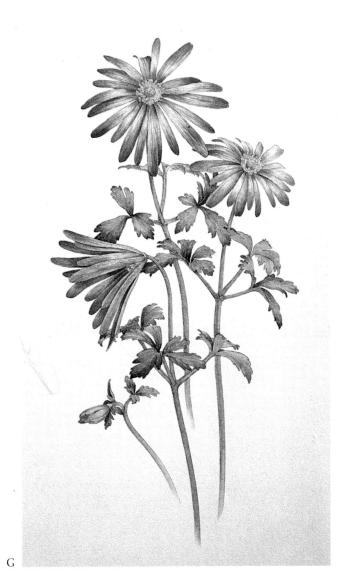

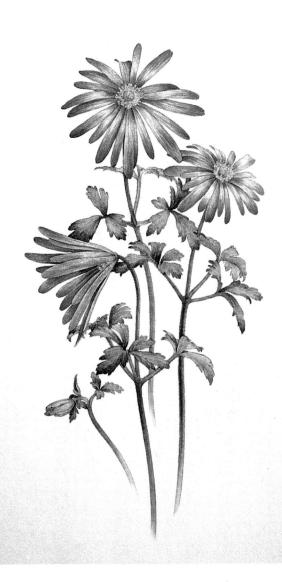

8. RHIZOME DRAWING [I]

By this point I had decided to include a rhizome. One was dug up, washed, and allowed to dry. In drawing the fine roots I aimed at a correct impression – there was nothing to be gained in following every fortuitous twist and turn.

Н

39

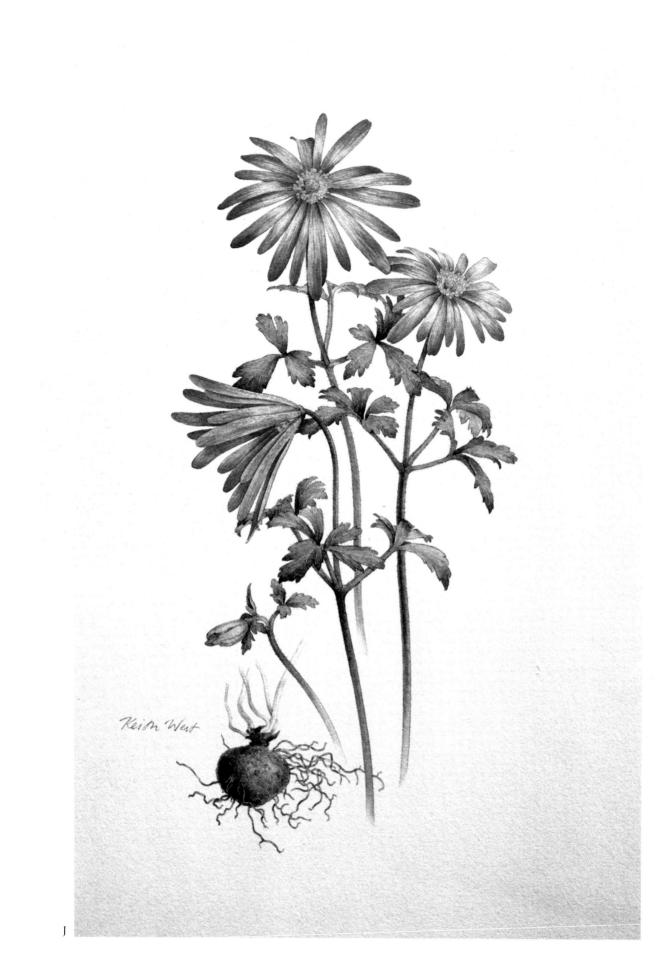

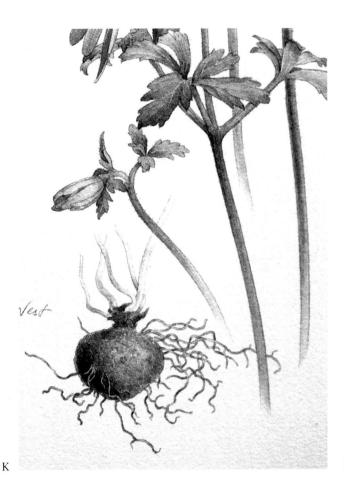

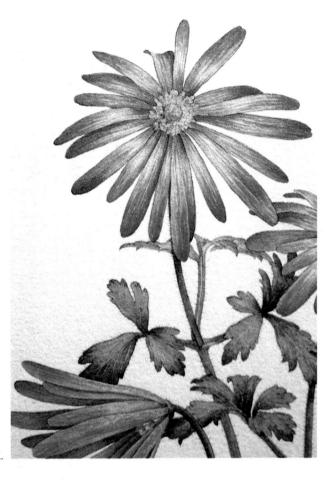

9. RHIZOME PAINTING [J, K, L, M, N]

After establishing the tonal balance of the rhizome with the usual shadow colour, the local colour of the rhizome was achieved by the addition of a little chrome yellow to the wash. This was applied in small strokes to imitate the texture of the surface (see detail [K]).

Rust-coloured markings on the stems emerging from the rhizome were dry-brushed using a mix of Winsor red, chrome yellow, and a drop of French ultramarine. This hue was modified with more French ultramarine for the scales at the top of the rhizome and for the roots where it was applied with a grade 'o' brush.

J. Windflower, *Anemone blanda*, garden, March 1990.

Ν

7 IRIS, *Iris sibirica* cultivar Family Iridaceae

The genus *Iris* contains some 300 species, in the wild confined to the northern hemisphere though now gracing gardens worldwide. The species of *Iris* and their hosts of cultivars are divided for convenience into four sections: bearded; beardless; crested; and bulbous – and these sections are further subdivided. Within the basic flower-structure, see below, the variation in form and colour is extraordinary. The name derives from Iris, Greek goddess of the rainbow.

Irises have given pleasure, challenge and employment to botanical artists over centuries. Outside this specialist field great artists such as Leonardo da Vinci, Bellini and Dürer, the Flemish and Dutch painters, the Pre-Raphaelites, and, of course, the much favoured van Gogh, as well as innumerable others, have all featured irises.

Though here I have chosen a tall species, it would also be a worthwhile project to treat one of the dwarf forms much as I did the snowdrop – showing the plant in a garden or, if feasible, in its native setting.

Paper: stretched Arches 90lb NOT. Image area: 272×125 mm.

1. DRAWING [A, B]

Iris stems were placed in 'oasis'. Several leaves were held in a waterfilled jar.

The iris flower might seem complicated until its parts are identified. There are only three basic units, each repeated in triplicate, in all the flowers in the genus. The erect petals are the *standards*, the drooping petals are the *falls* and the smaller arching components, each hiding a single stamen, are the *petaloid style-branches*.

To begin, the left standard of the upper flower was drawn, followed by the front-facing petaloid style-branch with its subtending fall petal (the venation of the petals was left till later). The same sequence was followed in drawing the rest of the flower. Remnants of a shrivelled flower at the rear were shown on either side of the central fall.

In order to catch a developmental sequence, I again held off from completing the petal venation to concentrate on the opening flower at the left. The new bloom was orientated to show the floral structure from a different angle. In this instance, though starting with the left standard as before, I then drew the right standard next, followed by the left petaloid style-branch. Next came the

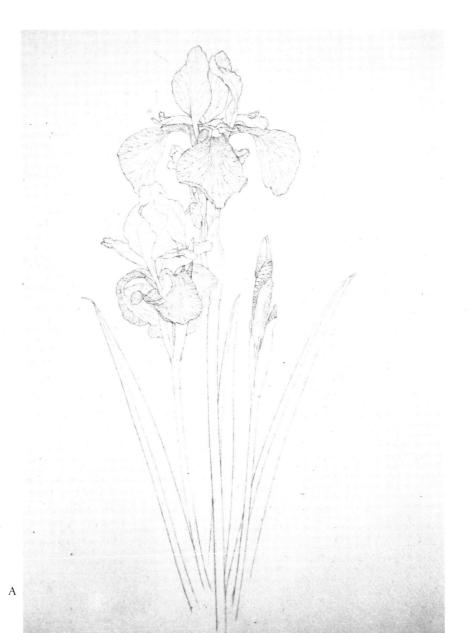

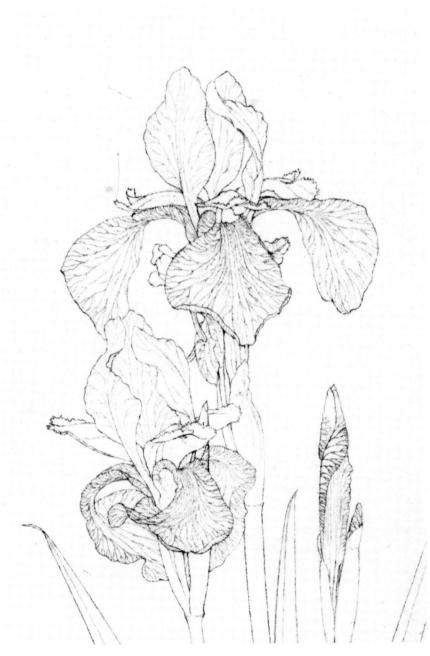

В

centre hind standard and centre petaloid style-branch with its fall. Under this fall a spathe-valve (sheathing bract) was shown. The left fall was drawn, and this was followed by the tightly folded bud, with its bract, immediately to the right of the centre fall. The right petaloid style-branch and fall completed the flower.

At this point the fairly complex venation of the falls of both flowers was pencilled in: the central vein was first drawn with the side veins following. Then the delicate venation of the standards was lightly indicated.

Before finishing for the day, the stems of the two flowers were completed. Also, to round off the picture, I sketched in loosely positions for a bud to the right and for three leaves. The following morning I found that the upper flower had withered and the lower flower had moved its structures into the fully developed phase. More flowers were picked to duplicate the phases of the previous day. The stem carrying the buds on the right was placed in 'oasis' and drawn, together with the upper parts of three leaves.

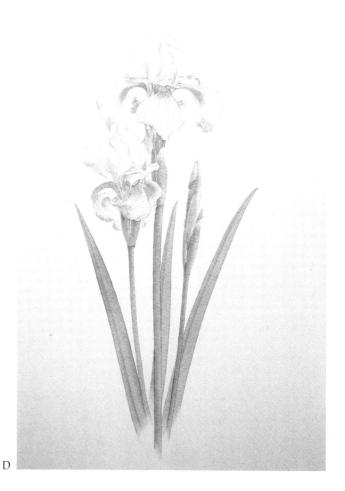

2. SHADING [C]

С

The shadow mix (p. 13) was used first on the upper flower, followed by the lower bloom and the buds to the right. In working on the stems it was helpful to pre-dampen each before adding the wash – this slowed drying to make it possible to blur and soften the right edge of the shadow every couple of inches or so as I worked down.

The shading of the leaf surfaces was affected by the way the modelling changed at the main veins. A thrown shadow was shown on the left leaf. Shadows were deepened in places.

3. FIRST GREEN COAT [D]

A pale yellow-green was mixed from chrome yellow and Prussian blue and this was used for all vegetative parts. Further diluted, the wash also coloured the larger flower-bud as well as the undersides of the central portions of fall petals. The left leaf apex and the upper parts of the spathe-valves were left unpigmented (later to be painted brown).

4. FLOWER BLUES [E]

In analysing the colours of the flowers I saw that the blue of the standards and petaloid style-branches contained more red in its make-up than the blue of the falls. To meet this difference a wash was first made from French ultramarine with a touch of violet; half the mixture was then poured into a second palette. More violet was added to one wash for the standards and petaloid stylebranches, the other wash was used for the falls.

The colour for the falls was drybrushed, following the venation so that I could work in small discrete areas. The blotches and minute dots of colour were also carefully placed.

The mix for the standards and the petaloid style-branches was washed in with highlights being lifted out while the pigment was still damp.

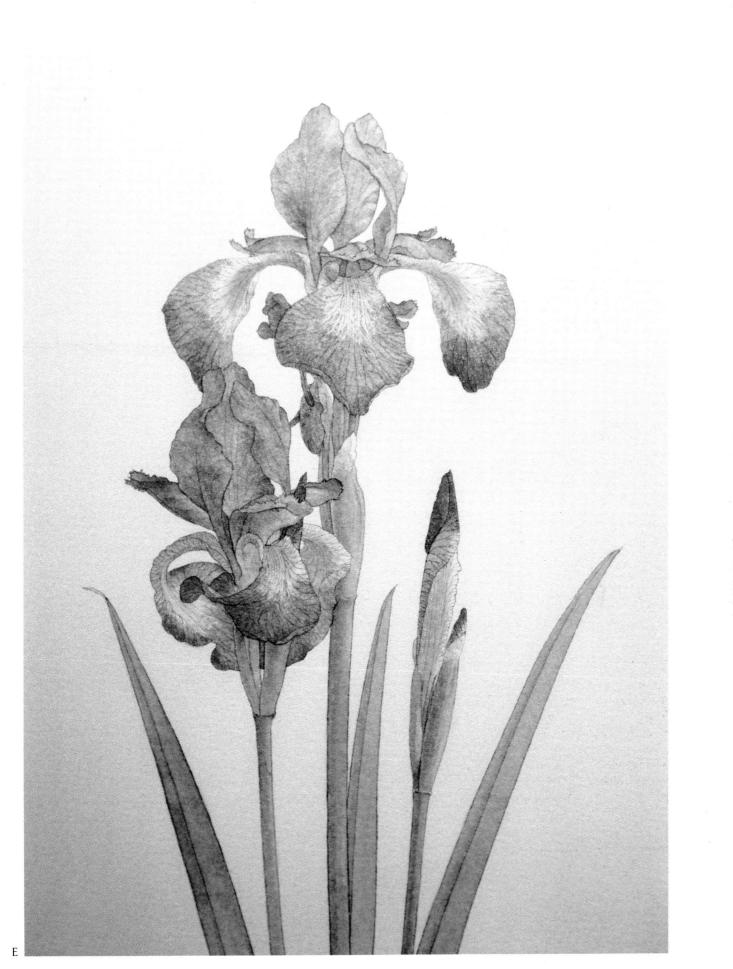

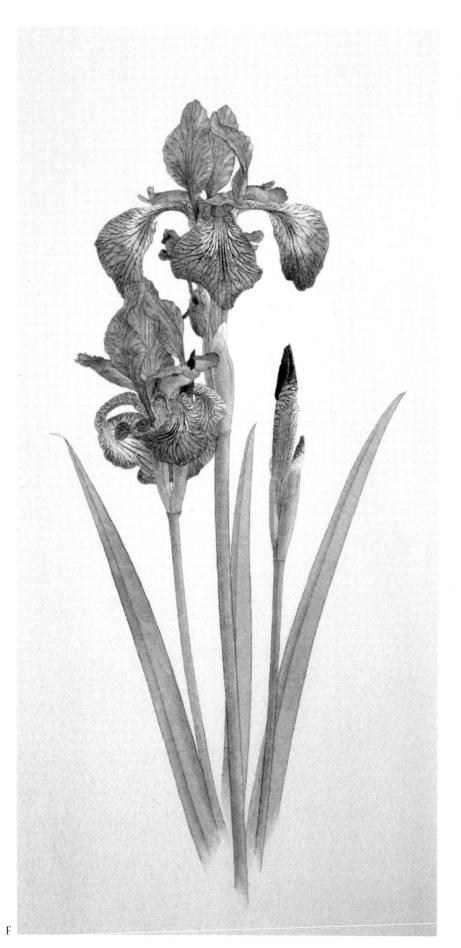

5. FLOWER VENATION [F, G]

An intense mixture of violet and French ultramarine was used with a grade 'o' brush for the prominent venation of flowers and buds.

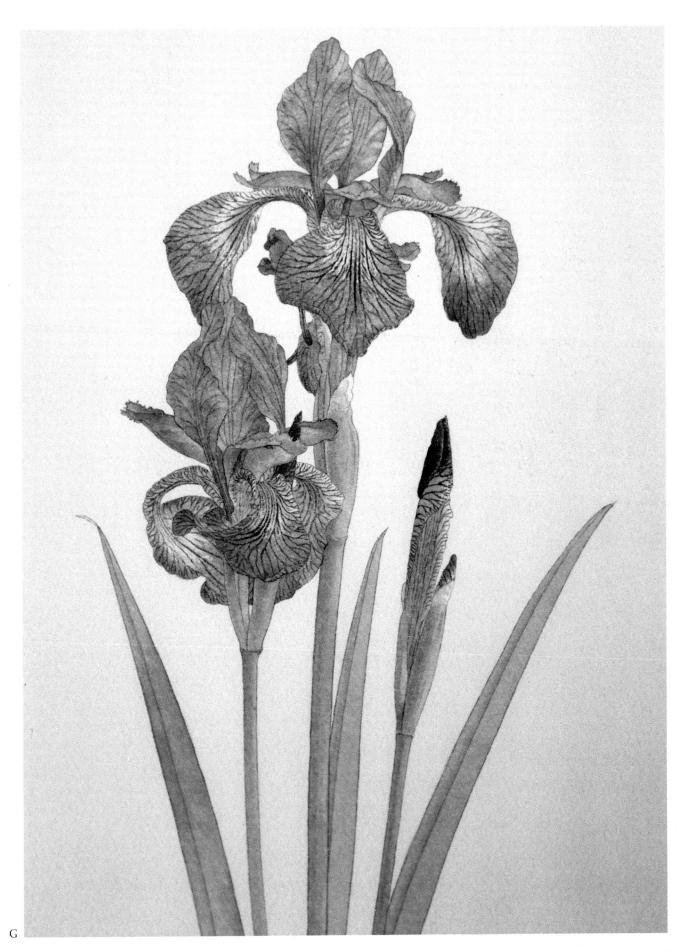

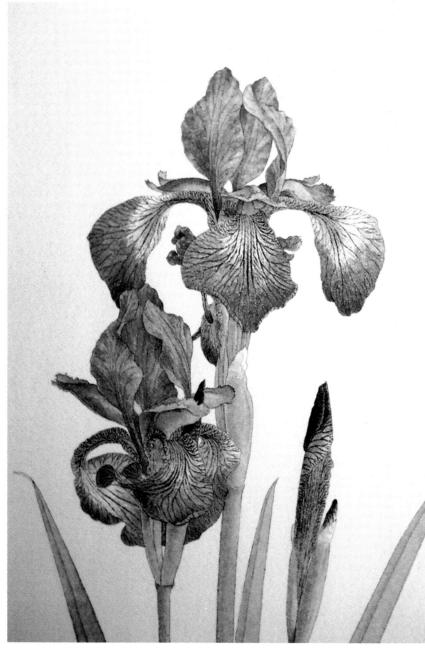

6. ADDITIONAL FLOWER Colours [H]

The venation colour above was diluted somewhat and used with drybrush to enrich some floral parts. The deep velvet colour of the bud tips needed several coats.

To capture the warm flush at the top of the falls, a wash of chrome yellow was first added, this colour also appeared on the larger flower-bud. In the same areas alizarin crimson with a dab of French ultramarine was used with a grade 'o' brush over the veins, and also in minute speckles and splodges between the veins.

7. SECOND GREEN COATS AND FINISHING TOUCHES [1]

Prussian blue was added to the original yellow-green and this was drybrushed onto the stems and bracts. To suggest the parallel veins of the leaves the same pigment was applied in narrow bands leaving an almost microscopic gap between each. I felt that the result still left the leaves looking a mite too yellow-green. This was corrected by a modifying wash of pale Prussian blue with a spot of alizarin crimson.

For the spathe-valve tips and the apex of the left leaf, a light brown was mixed from chrome yellow and alizarin crimson with a dash of French ultramarine.

Finally the shadow mix was used to add extra emphasis here and there.

I. Iris*, Iris sibirica* cultivar, garden, May 1990.

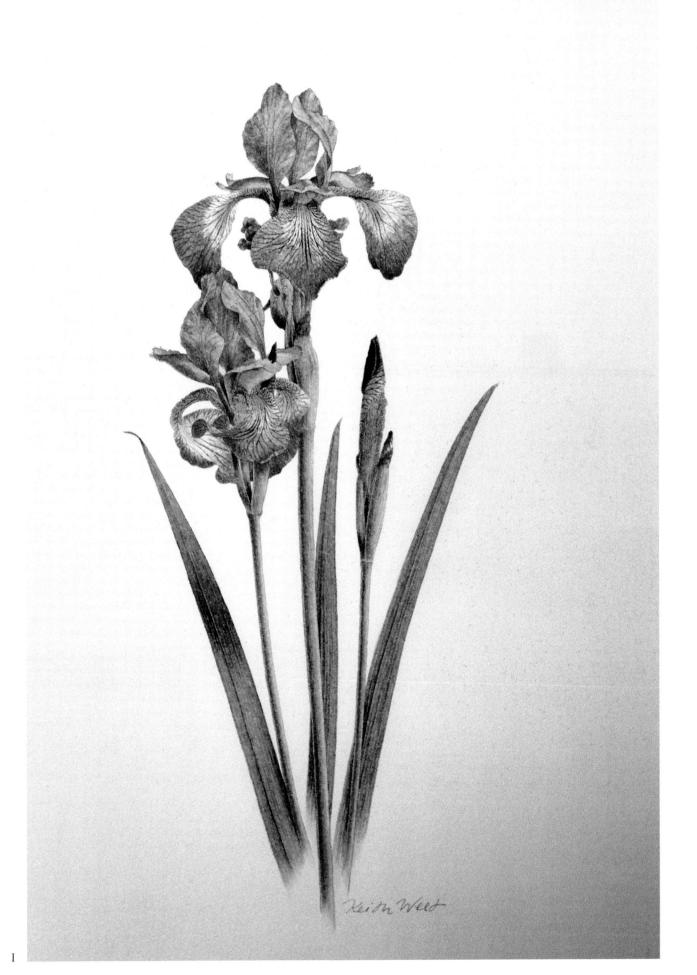

8 PINK, *Dianthus* cultivar Family Caryophyllaceae

As well as pinks, the genus Dianthus includes carnations and sweet williams among its 300 species. The generic name comes from the Greek, *Dios* – of Zeus; plus anthos – flower, the 'divine flower'. The origin of the vernacular name is obscure, though different explanations have been suggested. One of the more convincing is that the flowers bloom about Pentecost. The German word for this is Pfingsten, and it is a short step from this to 'pink'.

Most garden pinks are the products of the plant breeder. They vary in being doubles or singles, in petal markings, and in the degree, or absence, of dissection of the petal margins – as well as in lesser features.

The perfume of pinks is a powerful attractant to the humming-bird hawk moth. My wife and I have

closely watched one of these strange creatures feeding from clumps of the pink illustrated. With blurring wings, a high-pitched hum, feather-like scales fringing the abdomen and an extruded proboscis probing beakily - the moth could easily have been mistaken for a tiny bird.

Such memories and connections enormously heighten the enjoyment we derive from favourite flowers.

Pinks are comparatively easy to draw and if several varieties are available you might consider a selection in one painting.

Paper: stretched Arches 90lb NOT. Image area: 250×135 mm.

1. DRAWING [A, B]

Stems carrying flowers and buds were placed in 'oasis'.

While it was still semi-closed I began by drawing the bud at the upper left together with part of its stem. The central, upper, flower was then drawn complete with stem, buds and leaves, so establishing the rhythm of the composition. Beginning with the stamens, this was followed by the flower and stem on the right.

Next, the left flower was drawn starting with the minute petaloid structures in the centre (as the flower had newly opened the stamens had yet to emerge). The stem also was carried to the base of the plate.

2. SHADING [C]

The shadow colour (p. 13) was first painted on the stems and leaves. While doing this I noticed that the *stigmas* had arisen from the flower on the right and these were quickly drawn. For the delicate shading of the petals the shadow mix was further diluted.

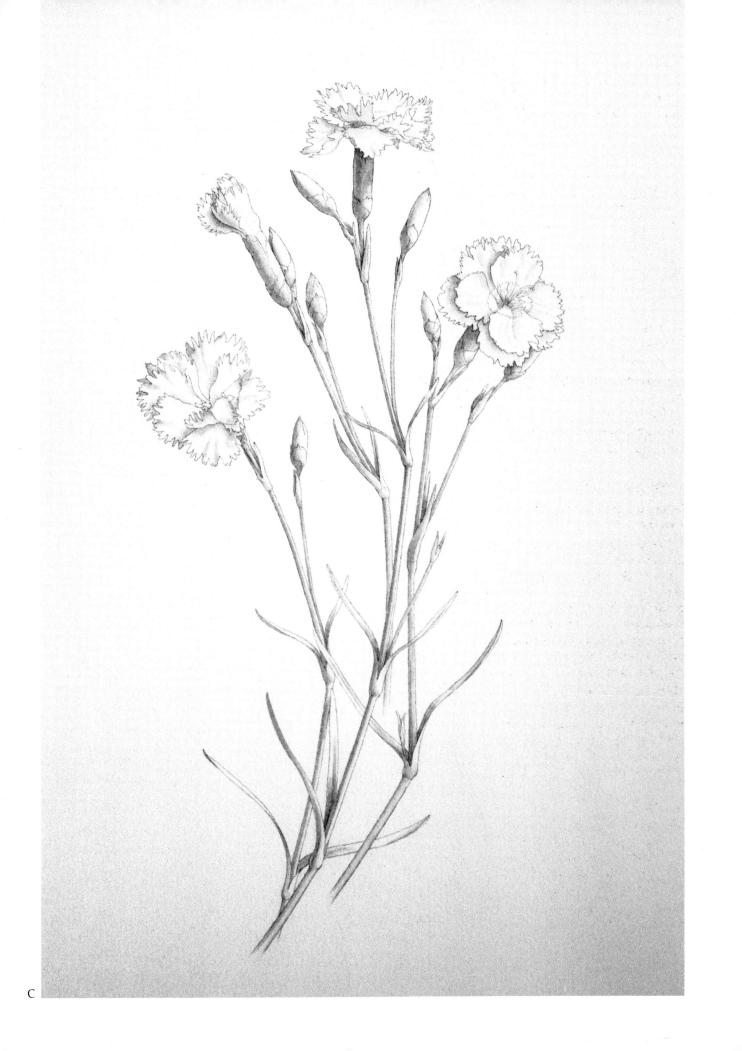

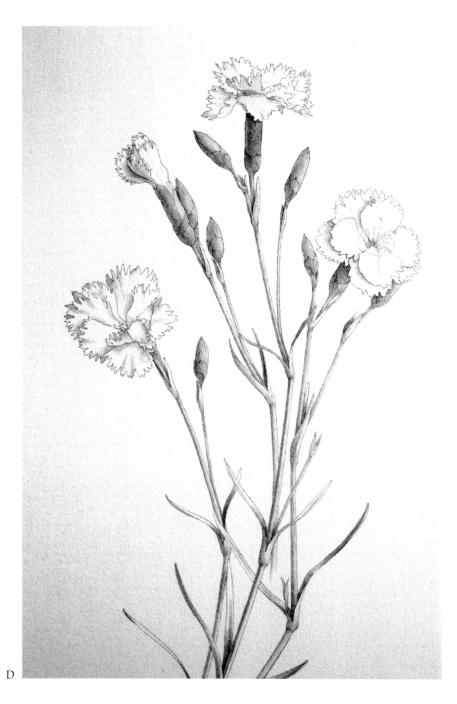

3. FIRST GREEN COAT [D]

A pale yellow-green was mixed from chrome yellow, Prussian blue and a brush-tip of alizarin crimson. This was used as a wash undercoat on the buds and dry-brushed as a light pigmentation at the fused leaf bases. The same hue was added in two coats on parts of the leaves to simulate their bright translucence against the light.

4. SECOND GREEN COAT [E]

The pastel blue-green of the stems and leaves provided a challenge for the transparent watercolour technique. An easy answer would have been to add white to create opaque gouache or body-colour, but this would have entirely changed the 'feel' of the work. In some situations it is impossible to avoid using opaque pigments, but here the white of the paper under a thin wash gave the correct effect – after a couple of trials on the practice sheet.

The blue-green was mixed from French ultramarine, chrome yellow and a stroke of alizarin crimson. It was applied with dry-brush to the narrow stems and leaves. In shadows two coats were used.

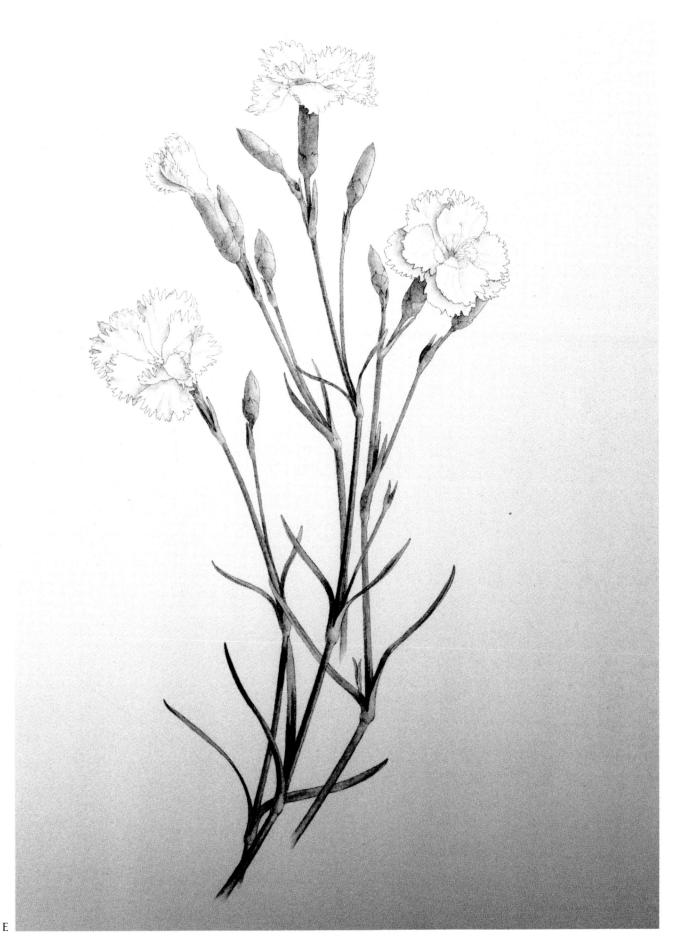

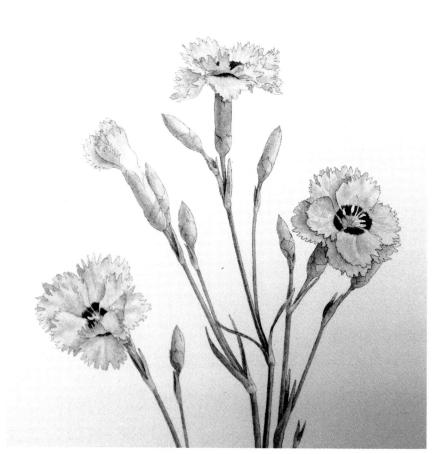

F

5. FLOWER COLOUR [F]

There is a temptation with very pale flowers to make their colours darker or richer than in life. I find that this should be resisted – faint coloration is often an integral part of a flower's charm.

A dilute wash of rose madder with a hint of magenta was used to achieve a very close approximation of the flower colour. The *exact* hue is available in a range of acrylic paints but I felt that for this work I should stay strictly within the range of transparent watercolours earlier recommended.

The wash was carried over the petals working around the frilly edges with a pointed brush-tip. Some colour was lifted off the palest places while it was still moist. On the unfurling flower the pink was faded out before the base of the floral tube was reached.

The vivid splotches on the petals were made using a mixture of rose madder, magenta and alizarin crimson. The colour was dry-brushed on, taking care not to exceed the actual areas involved.

6. FINISHING TOUCHES [G, H]

The petal marking mix was diluted and dry-brushed onto the buds for their reddish patterning.

At this point I felt that additional interest would be given by the insertion of a couple of details – the ovary with erect *styles*, plus a single petal. The petal was gently pulled from a mature flower. A central axis was lightly indicated first and the length of the petal was scaled off with dividers. Shading came first, then the flower colours used earlier were added. A little of the yellow-green used for the first green coat was dry-brushed onto the lower, strapshaped, part.

The ovary with erect styles was teased out from an apparently hermaphrodite flower (some of the other flowers had much reduced styles – presumably being functionally male). Before drawing the ovary, minute sculpted scales were excised from about the base with the tip of a scalpel. To achieve the fine detail the pencil lead was kept needle sharp. Shadow colour defined the styles and the roundness of the ovary. The yellowgreen of the petal base was used for the ovary, and palest magenta was dry-brushed onto the stigmatic tissue.

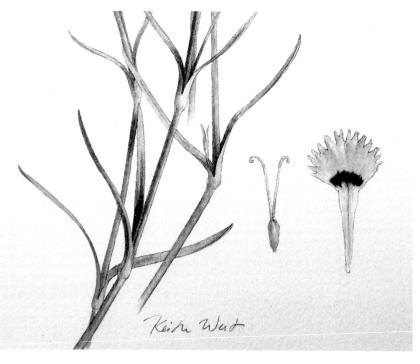

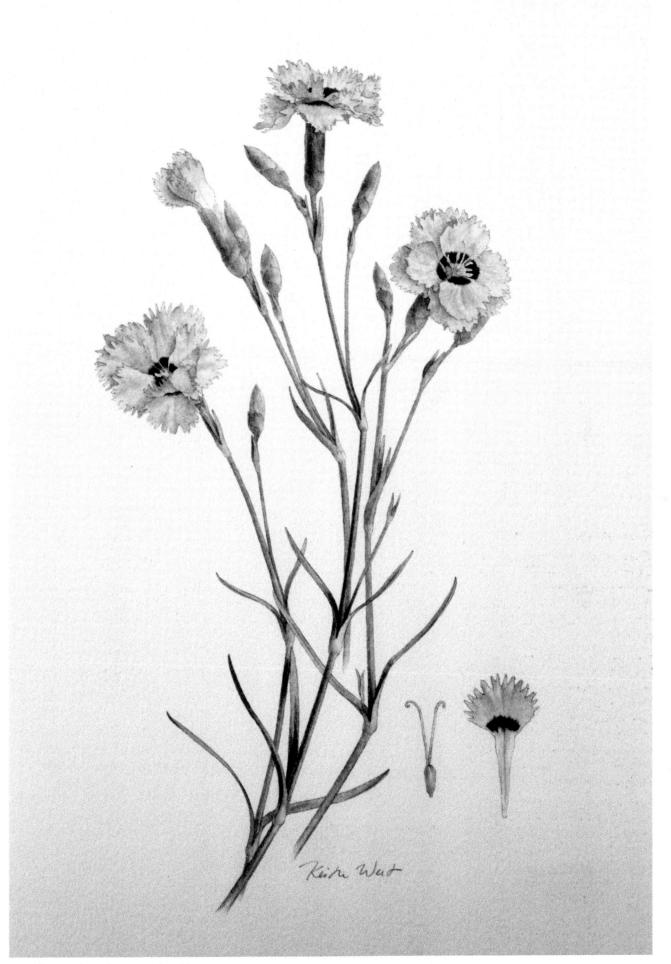

G. Pink, *Dianthus* cultivar, garden, May 1990.

9 FIELD POPPY, Papaver rhoeas Family Papaveraceae

The poppy family contains many superb subjects. Favourites include the Iceland poppy, *P. nudicaule*; the alpine poppy, P. alpinum; and the present subject, P. rhoeas, together with the charming 'Shirley' mixtures developed from it. The genus Meconopsis yields the blue-flowered M. betonicifolia and *M. grandis* from the Himalaya, as well as the Welsh poppy, *M. cambrica* in both yellow and orange. The large-flowered prickly poppies of the Americas in the genus Argemone are striking, but are too big to be portrayed life-size without considerable experience. The same is true of the giant *Romneya* species of the United States, though not of the California poppy which is scaled to fit on a drawing board even if its name Eschscholzia californica is not so easy to accommodate on the tongue.

The field poppy is the best known wild member of the family in Britain. In spite of farmers' efforts it remains a spectacular presence in corn fields.

An unusual characteristic of the poppy flower is that the petals hold a crumpled appearance long after emergence from the drop-away calyx. This attractive texturing is suggested in the painting by the dappling of shadow.

Ruskin wrote of the field poppy: 'it is painted *glass*; it never glows so brightly as when sun shines through it. Wherever it is seen – against the light or with the light – always, it is a flame, and warms the wind like a blown ruby.' Unfortunately this bright petal translucence is beyond capture in watercolour – though a very dark background in heightening contrast will help to a degree.

Paper: stretched Fabriano 90lb NOT. Image area: 345×180mm.

It has been several years since I last used Fabriano paper and I had forgotten its qualities. It might well be ideal for some purposes but the paper did not perform well for this type of botanical painting. The surface was agreeably textured but it tended quickly to break up after the application of more than one coat and consequently it had to be treated gingerly.

1. DRAWING [A, B]

A number of specimens were collected and allowed to settle overnight in a cool room with their stems deep in water. From previous experience I was aware that poppies have a tendency to wilt for a while after picking.

The following morning one large stem was placed in 'oasis'. It carried several flower-buds on the point of opening, and I assumed that in the dry warmth of my studio fresh blooms would soon open.

A skeleton framework was lightly sketched in with areas at top centre and top left being reserved for flowers. At the very top I intended later to place a ripening *capsule*.

The bud at the top right was drawn first. Though hairs were to be left until the final stages, I recorded the roughish texture of the bud surface caused by the minute swollen hair bases. (This feature occurred only on the buds and not elsewhere other than to a barely discernible extent on the leaves.)

The stem carrying the bud was completed, continuing down to the base of the plate. Finishing this part I willed some of the flower-buds to open but without success, so I turned to other matters for the rest of the day.

The next morning there were more blooms. One still tightly crimped

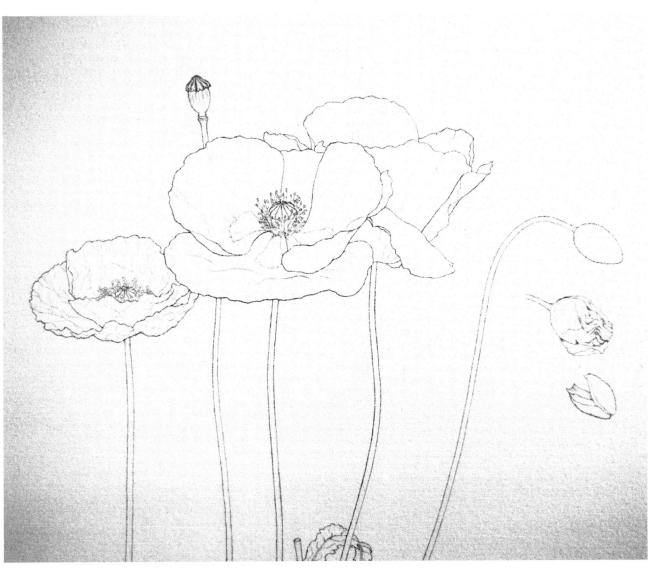

petal mass had just broken free from its calyx and this was drawn immediately as the detail shown on the right. Had I not been doing the plate for this book I would have broken the sequence to paint this feature; but bearing readers in mind it seemed better to stick with the steps knowing that there would be other opening buds to use when needed. One smallish flower had just reached the 'goblet' phase. This was drawn on the left of the plate – starting with the top of the ovary – before moving on to the petals.

Another, more fully opened flower was placed at the top centre slightly overlapping the previous one. By this time a handsome larger flower, again of 'goblet' form, had developed. This was placed to the rear and right of the central bloom. Unfortunately the longish flower-stalks made it necessary to draw two in parts. Asterisks and similar devices are often used to indicate which stalks belong to which bases, but here I felt that there was no ambiguity.

The ripening capsule at the top finished the drawing.

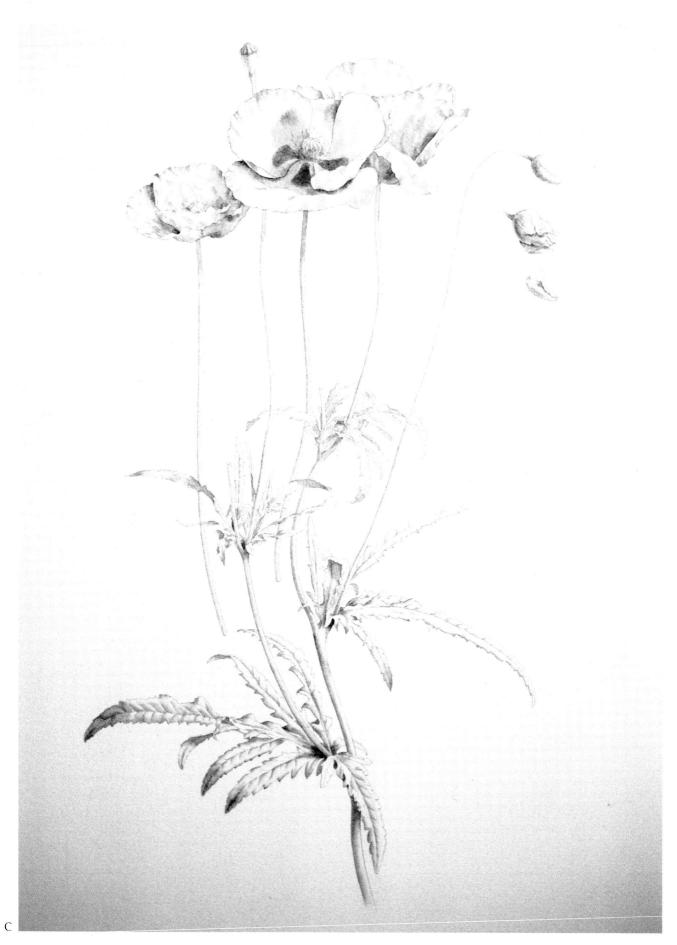

2. SHADING [C, D, E]

The shadow mix (p. 13) was applied first to the stems and then to the leaves.

I next worked on the flowers, premoistening some areas. In attempting to deepen tone by dry-brushing extra shadow into the dark markings on the central flower, I found that the Fabriano paper fibres were beginning to break up – leaving an uneven blotchiness. I therefore used a hairdryer to ensure that the surface was bone dry before adding subsequent coats anywhere.

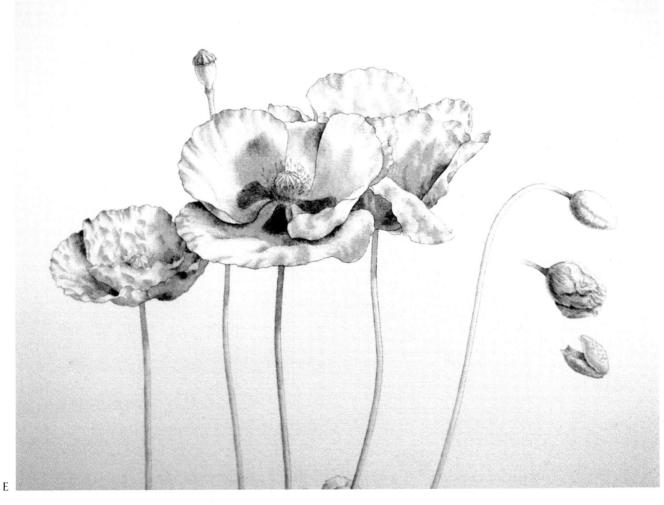

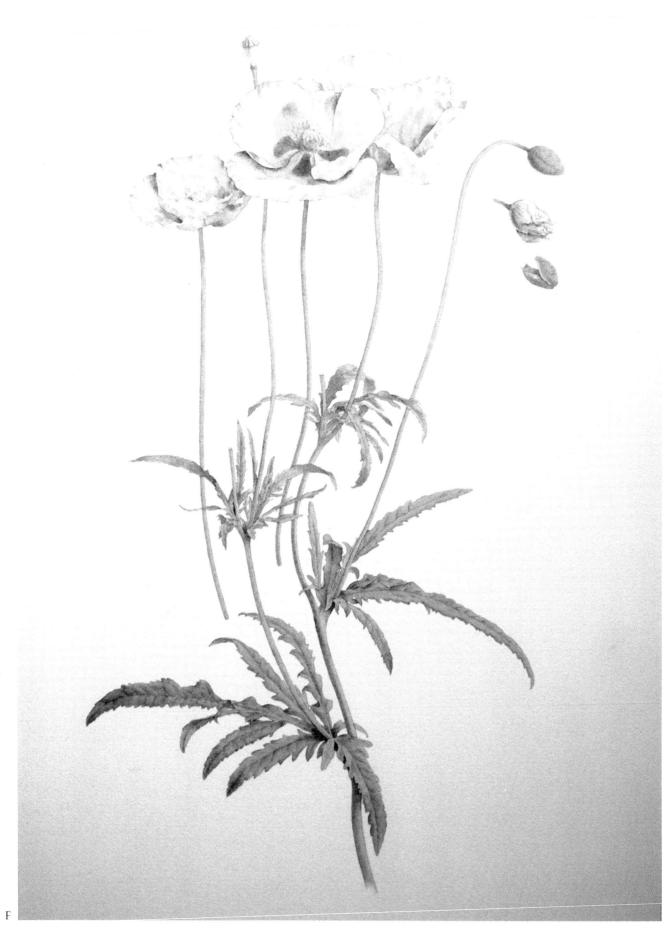

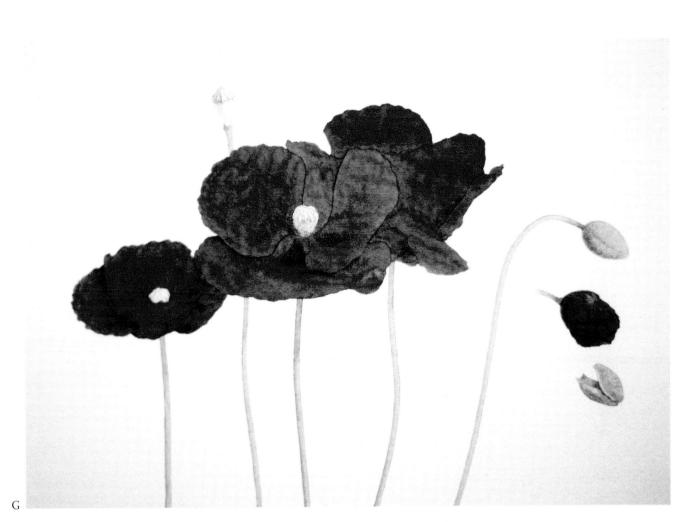

3. FIRST GREEN COAT [F]

An underlying green mixed from chrome yellow, Prussian blue and a speck of alizarin crimson was used for all the vegetative parts. The different greens of the ovaries and the ripening capsules were left until later.

4. FIRST FLOWER COAT [G]

A poppy red was made from Winsor red and a little chrome yellow. This was washed onto the opening bud at the right and then the flowers – skirting the ovaries. Again I was dissatisfied with the paper as the wash dried looking uneven, but I felt that this could later be corrected.

5. SECOND GREEN COAT [H]

More Prussian blue was added to the first green mix along with extra alizarin crimson. This was dry-brushed into the leaves and the darker parts of stems as well as the uneven surfaces of the calyces at upper right.

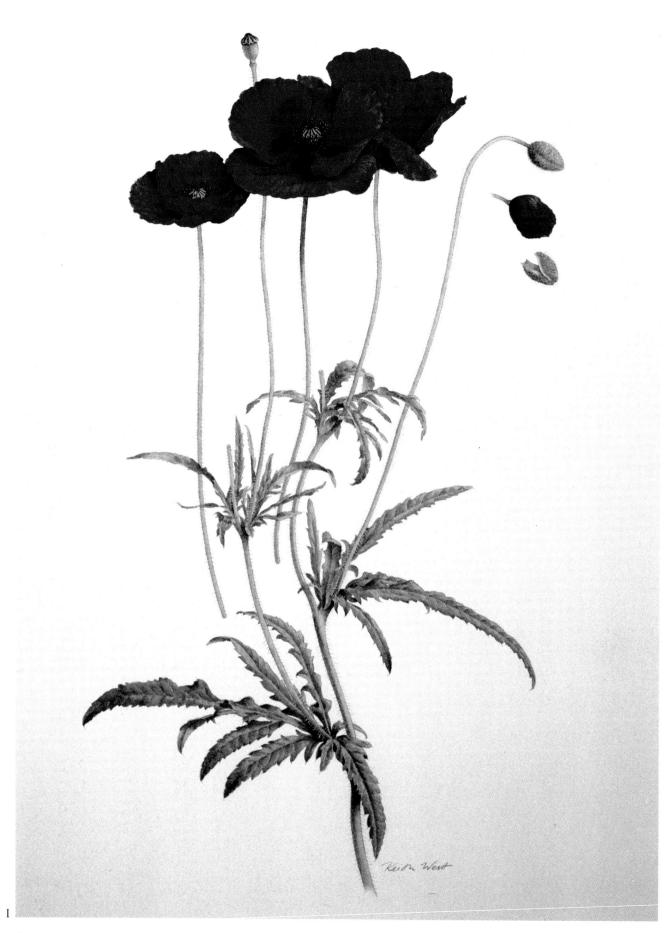

6. SECOND FLOWER COAT AND FINISHING TOUCHES [I, J, K, L, M]

Using the original flower colour the petals were enriched with dry-brush. The crinkly surface was emphasized and small strokes helped to obscure the uneven first wash.

Again, with dry-brush I worked on the dark markings at the bases of the petals of the central flower and at the base of the opening bud to the right. For this intense colour a new and concentrated shadow mix was made.

The second green coat colour was diluted for the 'caps' of the ovaries and the ripening capsule, then a little Prussian blue was added to the mix for the lower parts of these organs.

The intense shadow mix of the petal markings was used on the tip of a grade 'o' brush to line in the stamen *filaments* (stalks).

Greyish green pollen covering the *anthers* was shown with a drybrushed mix composed of French ultramarine, chrome yellow and alizarin crimson put on in small speckles. Then a small amount of white was added to this mixture to suggest some anthers which caught the light: these brighter points were too small to define without a little opaque pigment.

The radiating stigmatic tissue on the 'caps' of the ovaries and immature capsule were coloured with a grade 'o' brush using alizarin crimson with Prussian blue.

Next the intense shadow mix was diluted and dry-brushed to strengthen some of the shadows on the flowers.

Finally, the hairs were added with a very sharp 2H pencil; where they appeared against a coloured background they were shown in white using a grade 'o' brush.

I. Field poppy, *Papaver rhoeas*, wild, June 1990.

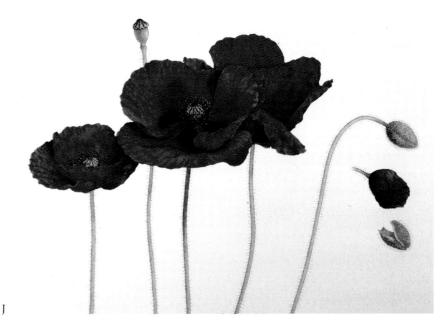

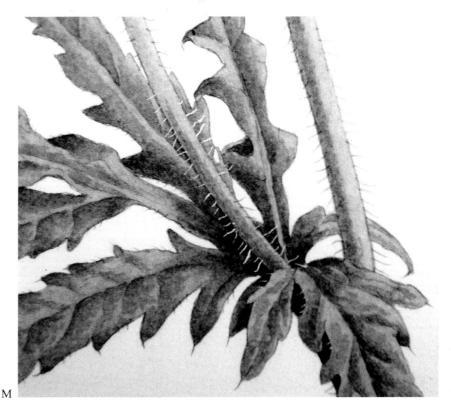

10 SWEET PEA, *Lathyrus odoratus* cultivar Family Leguminosae

Few of the 150 or so species of *Lathyrus* are cultivated. One of these, *L. odoratus*, has been developed to provide the many sweet pea varieties which range from dwarf plants to those which will climb to 3 metres or more. Hues are typically pastel soft though, as shown, some are richly coloured.

Once the characteristic structure of the flower is understood, see below, sweet peas are not too demanding to draw. The hooked tendrils are odd –

1. DRAWING [A]

After picking a selection of sweet peas I roughed in a layout for three inflorescences to show the best colours of this cultivar in our garden.

To begin, a stalk bearing three crimson flowers was inserted in 'oasis'.

It is helpful when working on any of the legume family to recognize that the petals are of three basic forms arranged, typically, so: an erect upper petal is the standard; the flanking two petals are the *wings* standing on each side of the *keel* – which enfolds the sexual parts.

The *irregular* flowers were each roughed in, to the right of the sheet, until I felt that the components were in correct alignment before being fined up.

Three blooms of a soft pinky red were chosen for the central position. If anything these flowers were even more flamboyantly convoluted than the first ones. Again they were lightly roughed in before completion.

In drawing the sweet peas there were no useful fixed starting points or sequences – for each flower these differed according to its orientation.

Before drawing the group of flowers on the left I thought it best to develop a portion of the stem with tendrils and leaves. I very lightly sketched the upper part of the stem with flowerbuds. Though I wasn't entirely happy animal-like in their blind groping for holds; when they touch a support, even their own parts, they twist into a tightly spiralled grip.

Blooming extends from June to September and so flowers may be portrayed when most convenient.

Paper: stretched Arches 90lb NOT. Image area: 325×210 mm.

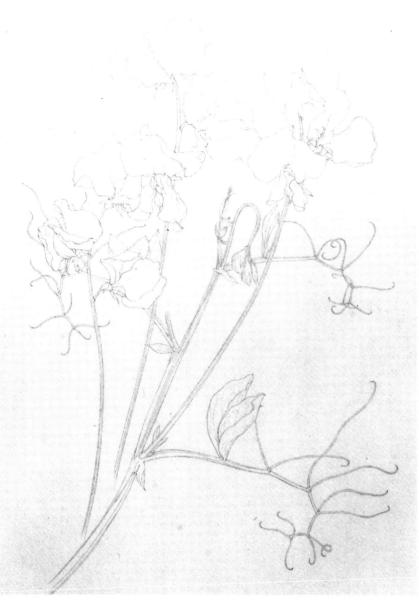

with its placement, the stiffly angular stem allowed little choice. A slight adjustment enabled the right-hand flower-stalk to emerge appropriately from an axil which had borne the stub from a cut flower. I continued working on the stem, temporarily leaving out the small branch curving to the left until the last, mauve-blue inflorescence had been established.

The leaves and the strange tendrils were then completed - the latter nicely rounding off the composition. With such closely spaced parallel lines as found in the tendrils, it helps to put in the upper line first, following its contours with the lower, second, line. And when parallels tend towards the vertical you will find it

В

best to draw the left one first if you are right-handed and the reverse if you favour your left. Finally, hairs were added with short strokes of the pencil.

2. SHADING [B, C]

By the time I came to work on the shadow pattern I found that the flowers, in a warm dry atmosphere, had rapidly passed their best. Fresh ones were picked, and by careful placement, these were satisfactory for providing the modelling for the individual drawn flowers.

First pre-moistening, I added shading (p. 13) to the flowers before moving to the stems and leaves. A grade 'o' brush was needed for the narrow twists of the tendrils.

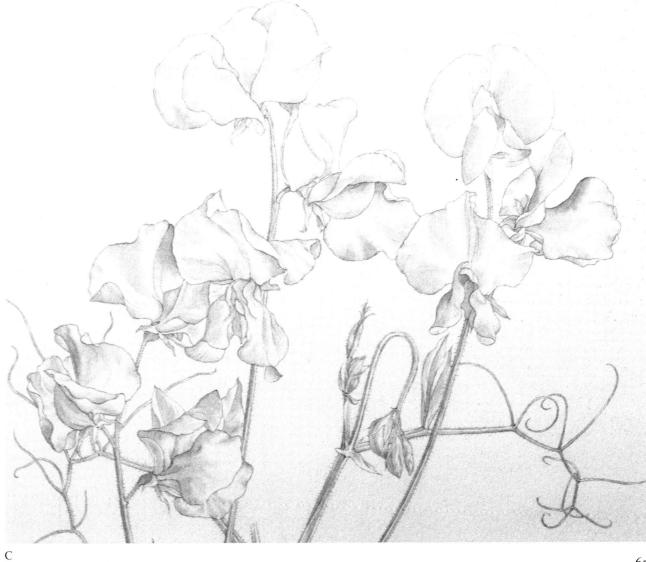

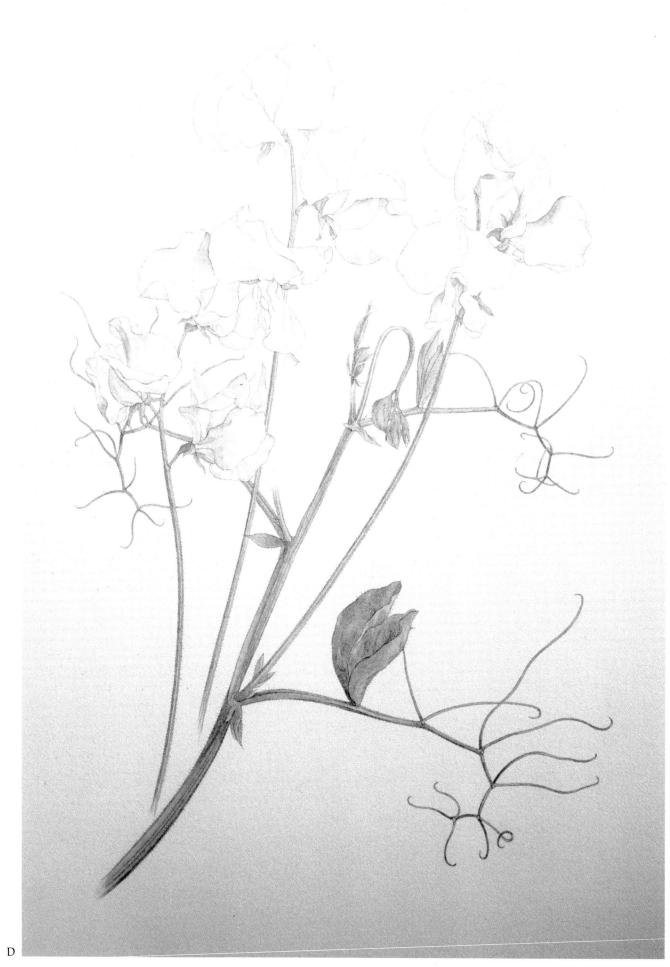

3. FIRST GREEN COATS [D]

A light yellow-green from chrome yellow and Prussian blue was used for calyces, tendrils and translucent parts of the leaves.

For the rest of the vegetative parts a blue-green wash was derived from Prussian blue, chrome yellow and a brush-tip of alizarin crimson.

4. FIRST FLOWER COATS [E]

I chose to start with the central spray of flowers and in studying them discovered a delicate colour gradation: the upper margins of the wings and the adjacent parts of the standards were flushed with rose madder blending into surrounding pale Winsor red. I first dry-brushed in a light tinge of rose madder and then, after moistening the ground, used a dilute wash of Winsor red.

After the central flowers I worked on the inflorescence on the right. For the standards and wings I used a wash of alizarin crimson and rose madder – lifting off some wet colour to suggest

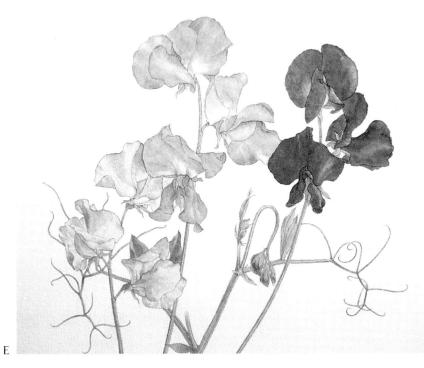

sheen. The same hue was used for the flush on the buds. Only small portions of the keels were in view and these were tinted with a mix of rose madder with a drop of violet.

In turning to the flowers on the left I found that the translucent green of the leaves behind the lowest bloom

5. SECOND COATS ON FLOWERS [F]

I returned to the flowers on the right and using the original mixture with dry-brush the petal colour was intensified.

In looking closely at the keels I found that, though the local colour was as described above, there was also a certain amount of reflected colour from the surrounds and this was lightly dry-brushed on.

For the central flowers more rose madder was added to the mix and dry-brushed to show that the wings were slightly darker than the standards. The lower parts of the standards and the whole of the keels remained light.

The violet of the left flowers was modified by a mix of French ultramarine with a touch of rose madder. Dilute violet was also applied here and there. Finally, at the bases of the standards of the upper and lower flowers, I used intense rose madder for minute bright veins.

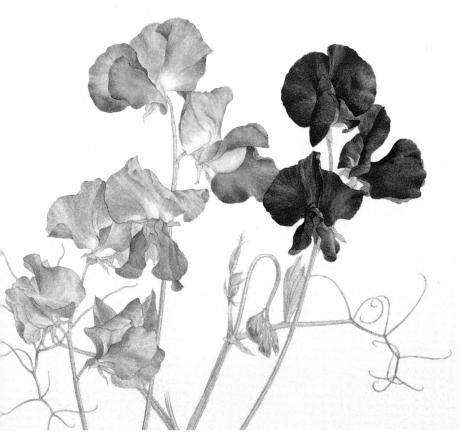

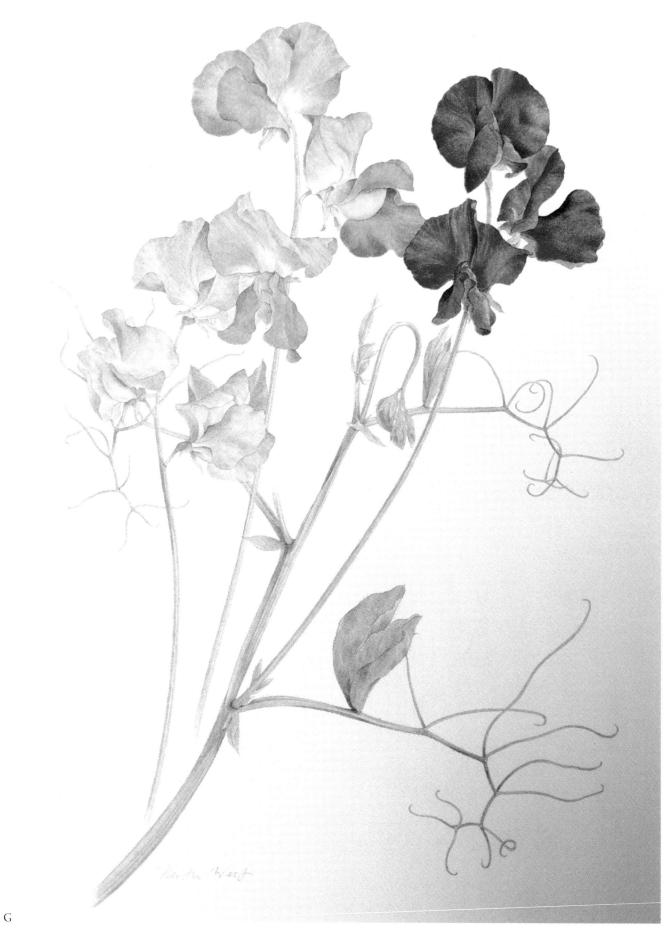

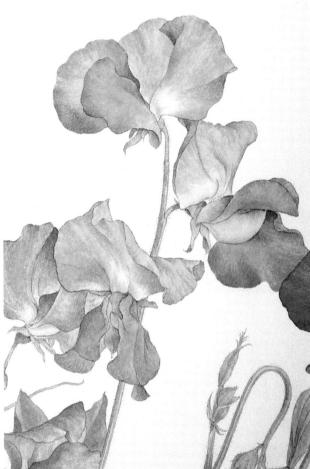

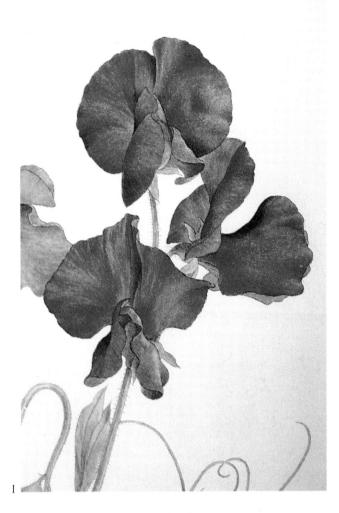

Н

6. FINISHING TOUCHES [G, H, I, J]

Accents of alizarin crimson at the bases of the leaves and the flower-stalks were dry-brushed.

Both the green washes used earlier provided depth for the vegetative parts.

Shadow colour heightened contrast in the darker parts.

G. Sweet pea, *Lathyrus odoratus* cultivar, garden, July 1990.

J

11 ROSE, *Rosa* 'Super Star' Family Rosaceae

In the palace of King Minos of Crete, roses were painted in frescoes dating from between 2000 and 1500 BC. The flower has featured in legends and stories, paintings and books for millenia. It has been used as a potent symbol by religious groups and political factions from the houses of York and Lancaster in the Wars of the Roses to the British Labour Party of today.

Some 250 species in the genus are swamped by an enormous number of hybrids and cultivars. As may be imagined, the history of the garden rose in all its forms is interesting and complicated.

An inexhaustible supply of roses waits for the plant painter, with enough variety to satisfy any need for novelty. In working on the flower one is always aware of artists from the past; there are too many to mention in detail, but perhaps the best known is Pierre-Joseph Redouté with his famed *Les* *Roses.* The recent republication of the fine watercolours of Alfred Parsons in *A Garden of Roses* should also be watched for.

To me the rose has an exotic aura – conjuring the walled gardens of ancient Persia. This impression may come from childhood's Hollywood magic, but surely another main source must be *The Rubáiyát of Omar Khayyám* where the flower is named frequently.

The choice of 'Super Star' was directed partly by its being a splendid flower and partly by its availability at the right time. Though your selection may be based on other criteria the sequence of work suggested should still hold.

Paper: stretched Arches 90lb NOT. Image area: 340×225 mm.

1. DRAWING [A, B]

A single rose on a longish stem was placed in water in a jar with the flower at eye-level. I bruised the stem base to assist water absorption.

After faintly indicating the main axis I drew the expanding flower beginning with the large petal facing front. The other petals were then related to the first. I had to move quickly as by the time the flower was finished there had been a certain amount of movement in the petals.

The ragged calyx was then shown, followed by the stem and leaves. As I moved down the stem the *petioles* (leaf-stalks) were lightly shown, together with the midribs of the leaflets. The leaf margins were then roughed in before adding the main

veins and teeth. A savage looking thorn was drawn at the stem base.

I had intended to illustrate a tight small bud to the right but a burst of hot dry weather caused all the 'Super Star' roses to open together. With no buds available I decided instead to use an unfolding flower of elegant form. This was orientated in three-quarters view to show a different perspective from the upper bloom. The outline was sketched in to be sure that the position was agreeable. Then the petals were fined up and the stem was shown fading off behind the foliage of the first flower. Looking back I think that this stem would have been improved by some upper leaves – at the time I thought that they would have been confusing.

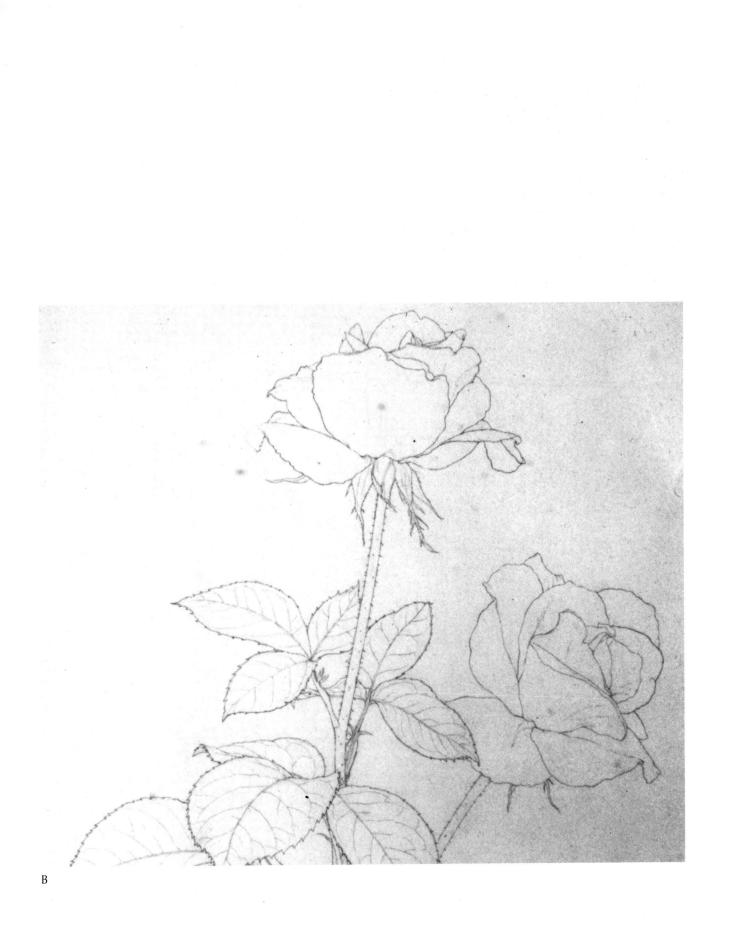

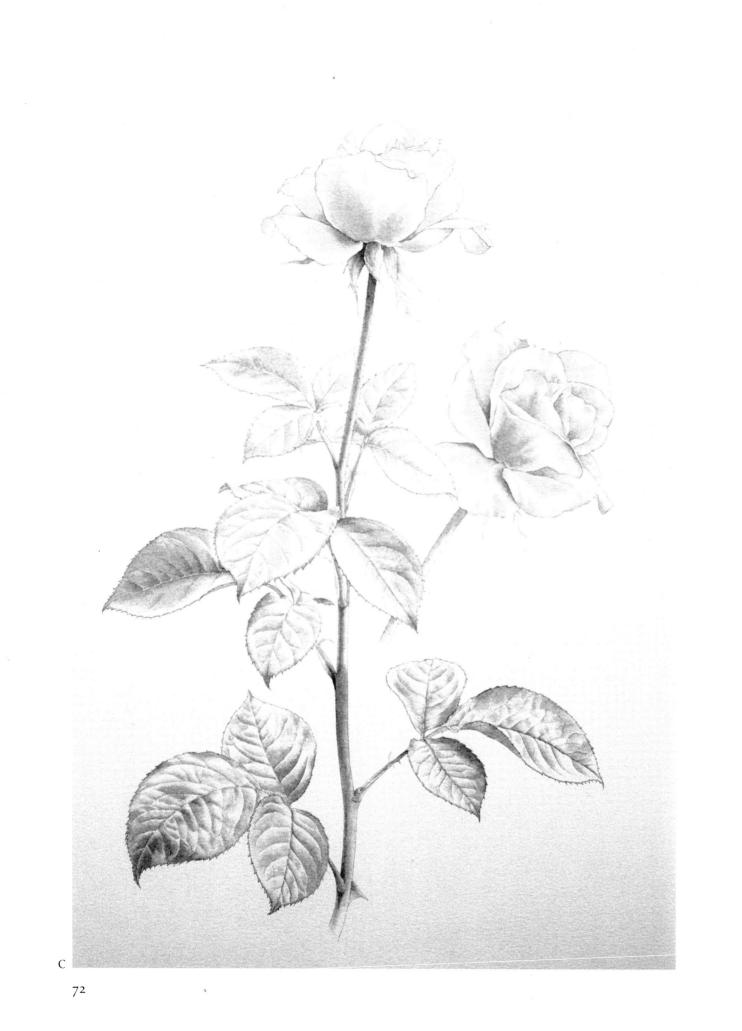

2. SHADING [C, D, E]

The shadow mix (p. 13) was added to the shiny leaves. Most areas were pre-moistened to give more time to lift off surplus colour before it became too dry (p. 16). Petals were treated similarly. When dry, second and third coats were dry-brushed where deeper tone was needed.

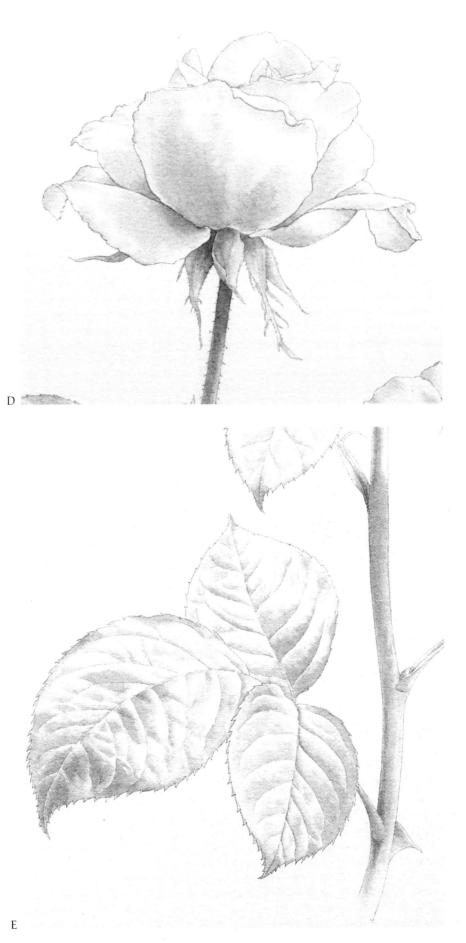

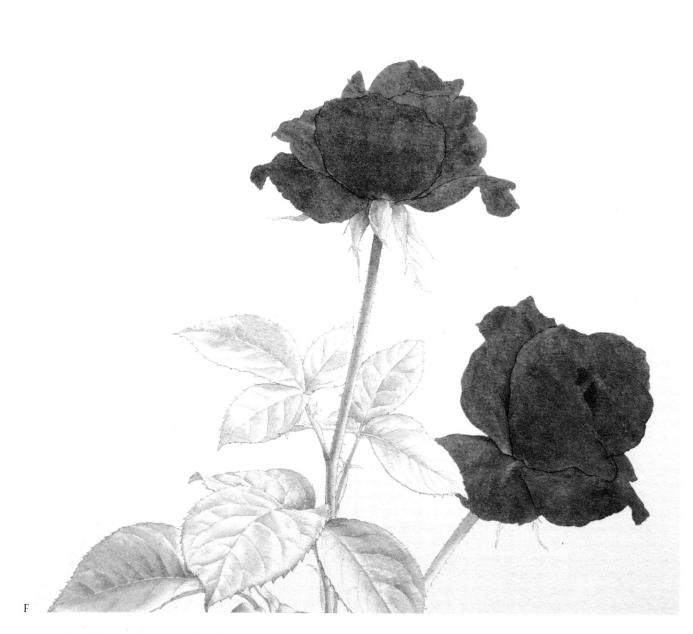

3. FLOWER COLOUR - FIRST COAT [F]

The flowers were opening quickly and I tried to catch their colour before they became overblown (rather than follow my usual sequence of using at least one green coat first).

I used a dilute mix of Winsor red and chrome yellow to match the petal hue. The colour was washed on with a little wet pigment being sopped up during progress to represent lighter patches.

4. FLOWER COLOUR – SECOND COAT; BLUE HIGH-LIGHT COAT [G, H]

The same petal mix was dry-brushed on in darker parts of the flowers to reflect their velvety texture.

Accents of chrome yellow were placed towards the base of each flower.

Dilute Prussian blue was mixed with a dash of French ultramarine for the sky reflected back from the highlights on the leaves. As the plant stood on the wide ledge of a large window this natural colour was evident.

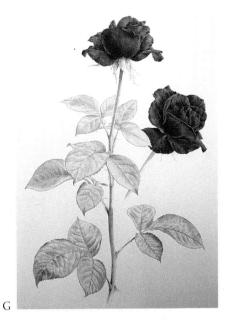

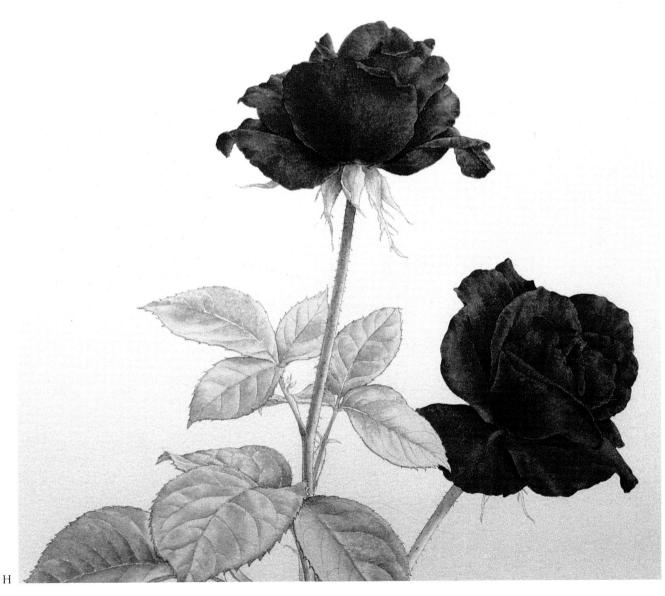

5. FIRST GREEN COATS [1]

A pale yellow-green wash came from chrome yellow and Prussian blue for the stems, calyces, and the veins of the leaves.

I followed this with a more intense

colour, a blue-green for the leaves – this was of Prussian blue, chrome yellow and a spot of alizarin crimson. It was dry-brushed with much blending and blurring (p. 16).

6. SECOND GREEN COAT FOR LEAVES AND FINISHING TOUCHES [J, K, L]

The blue-green leaf mix was used again to strengthen the existing patterns – the pigment was applied in small dabs to imitate the leaf surface.

The yellow-green stem mix enriched the colour of parts of the *stipules* and calyces.

A brown-red flush on the stems was realized by allowing the pale green already in place to show through a mixture of alizarin crimson and French ultramarine.

A touch of Winsor red was used on the single thorn and the shadow mix was added for slightly more emphasis on darker parts of the flowers to complete the work.

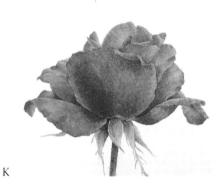

J. Rose, *Rosa* 'Super Star', garden, July 1990.

Ι

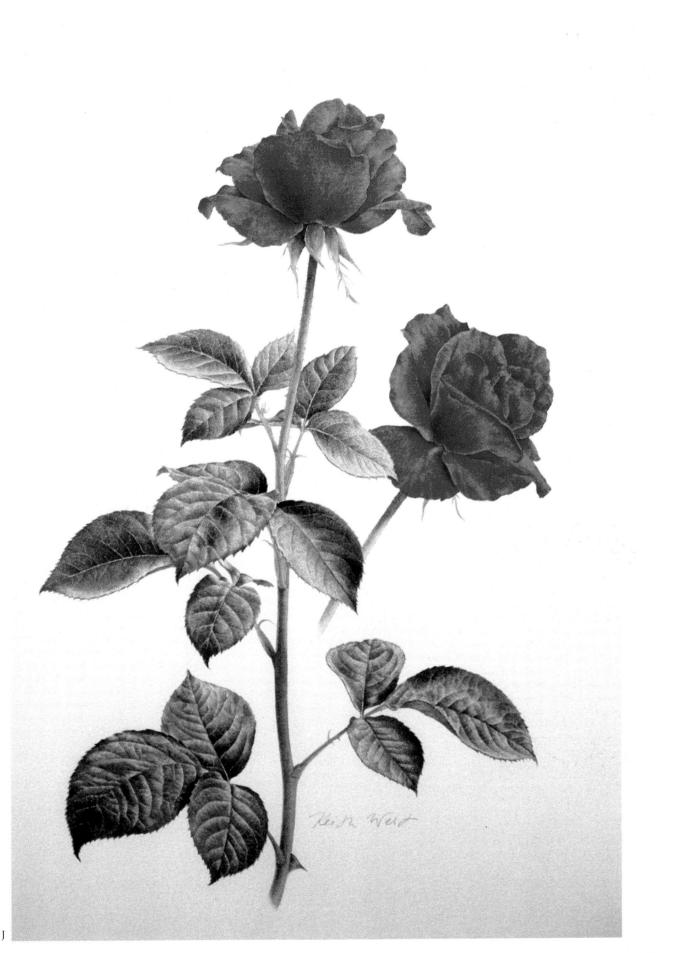

12 HAREBELL (bluebell in Scotland), Campanula rotundifolia; Family Campanulaceae

The harebell is a favourite flower – it recalls dry grassy places in open uplands with wide skies.

Though there are about 300 species in the genus, only twenty-five or so, plus hybrids and varieties, are cultivated. Generic, family and vernacular names all refer to the bell-shape of the flowers – though in some species they are star-shaped.

The present subject, *C. rotundifolia*, is native to much of the northern hemisphere. I have enjoyed painting this little flower in the tundra of Colorado's Rocky Mountains as well as from the hills about my home in Wales.

I collected these harebells on the day a drought

broke. No wide skies this time, we walked in low cloud and drizzle with the harebell blue relieving grey surrounds. A hawk scudded through the mist chased by small birds. On reaching home I found that almost every flower sheltered a resting tiny native bee, a species with unusually long antennae.

You might wonder about the reason for the specific epithet. This refers to the rounded basal leaves; but unfortunately, in my specimens, they had dried and shrivelled.

Paper: stretched Arches 90lb NOT. Image area: 265×140mm.

1. DRAWING [A]

At the start I was not sure how many stems to use so I dispensed with a preliminary framework. Keeping a number of flowers reserved in water, I placed one stem at a time in 'oasis' as I worked on it. The central inflorescence was drawn first, beginning with the upper flower. Next I drew the flower immediately below the first, followed by the apex flower and bud - to the rear of the first two blooms. Continuing down the stem to completion I used the same method for drawing close parallel lines as described for the sweet-pea tendrils (p. 65).

The left stem was drawn in a similar way, relishing the form of the flowers.

I had been undecided as to whether to add another inflorescence. At this point it did seem that more weight would be an improvement and I opted for more flowers on the right.

2. SHADING [B]

I added the shadow mix (p. 13) to the flowers and buds first, using lots of pre-moistening and blending (p. 16). Then, using a fine-tipped new brush I worked down the stems and their linear leaves. The central stem was emphasized to bring it forward.

A

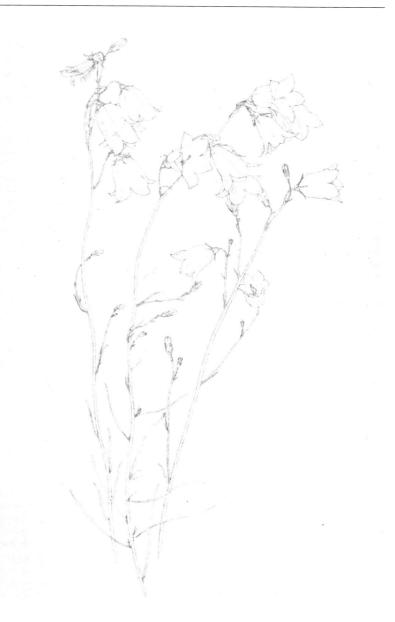

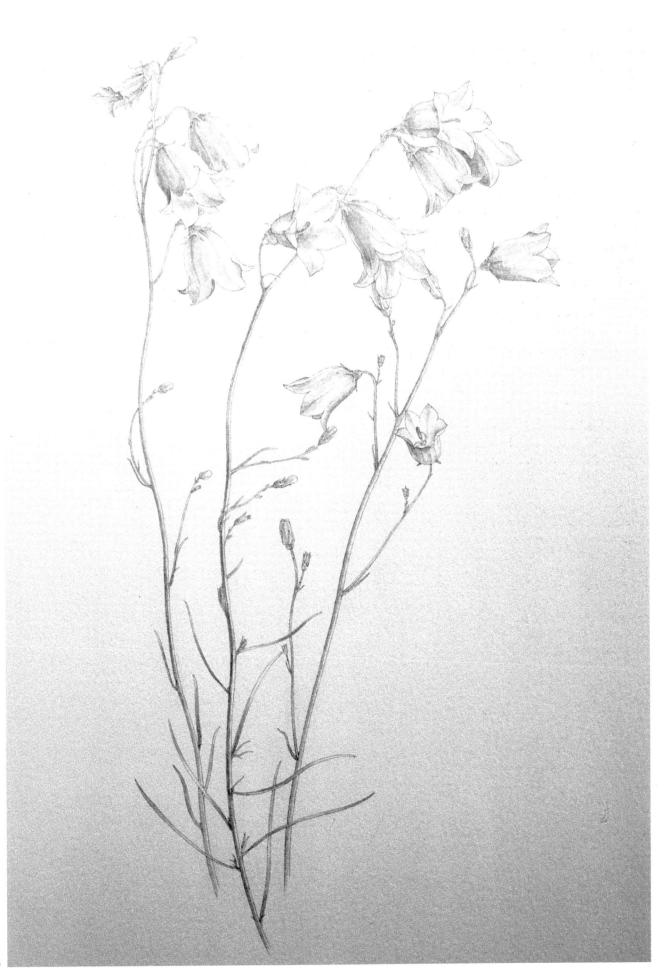

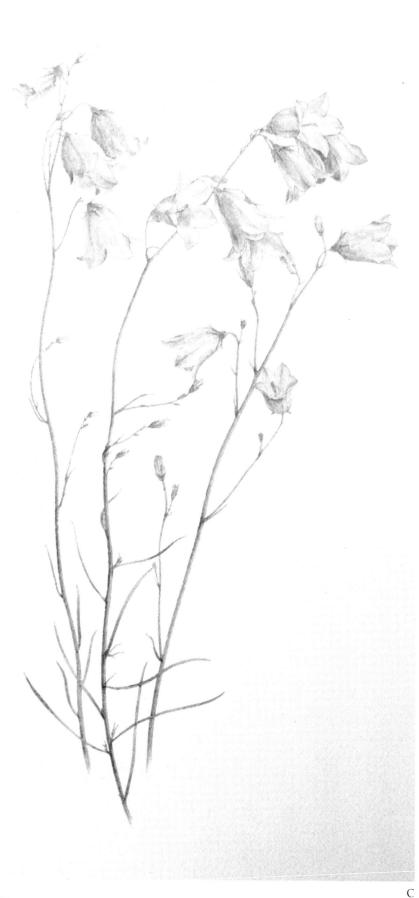

3. FIRST COATS [C]

For all vegetative parts I used a mixture of chrome yellow and Prussian blue; some of this was further diluted with more chrome yellow added for the flower-buds.

In the wild you can see that harebell flowers vary in intensity of colour (and size also). For this painting I chose some of the deeper-hued blooms. Even so, on any objective scale, they were still quite pale and I was careful not to exaggerate their blue. I tried several mixes before arriving at a satisfactory balance of dilute violet and French ultramarine.

4. FINISHING TOUCHES [D, E, F, G]

Once the above steps had been completed, little remained to finish this relatively straightforward painting.

Very pale brown from Winsor red, chrome yellow and French ultramarine coloured the opened anthers and the shrivelled flower at the top of the left stem (just showing behind an opening bud).

The flowers' colour was heightened using the original hue. Some of this mix also darkened the lower stem of the central inflorescence.

Finally, extra shadow was drybrushed on the centre stem.

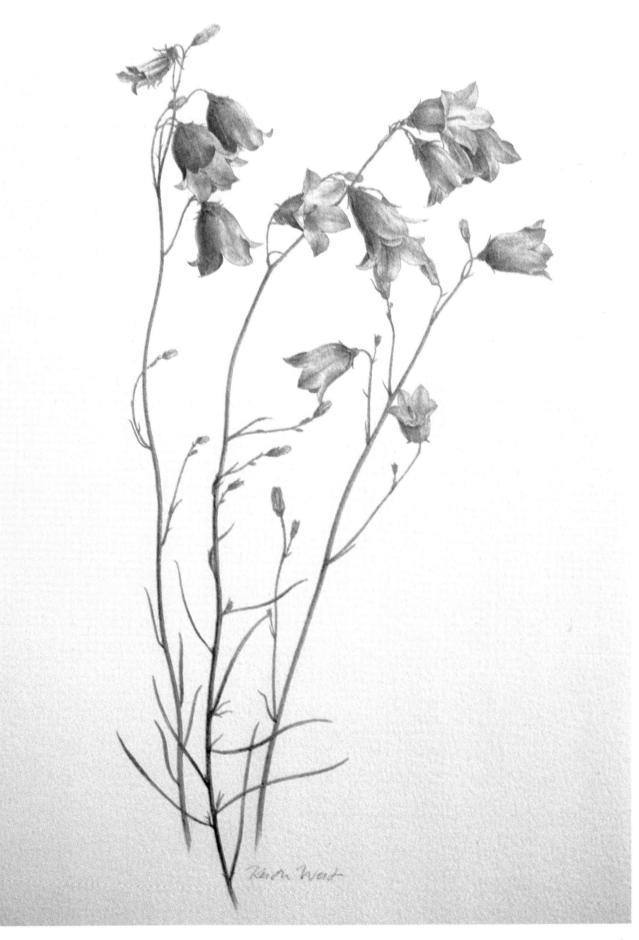

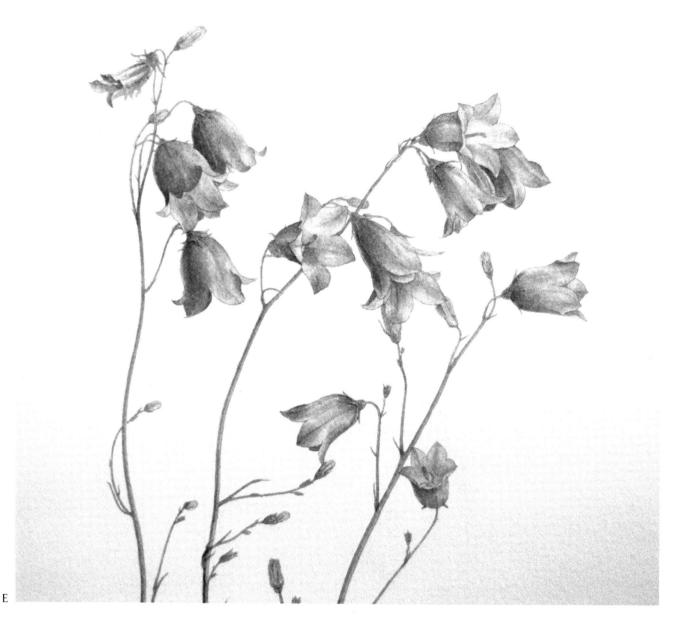

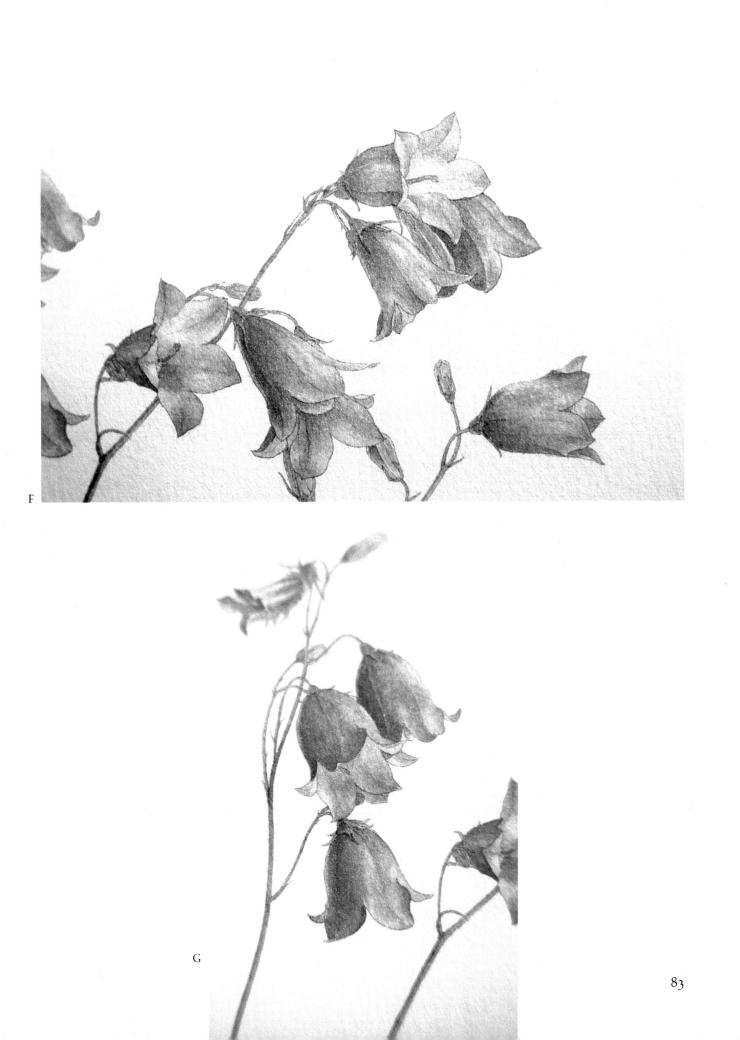

13 SUNFLOWER, *Helianthus* cultivar Family Compositae (Asteraceae)

On dull days the flowers of *Helianthus* gleam like patches of sunlight – especially if they happen to be of the large-flowered forms of *H. annuus*.

I have been unable to find a common name for the smallish-flowered form portrayed, but it will fit under the umbrella term of 'sunflower'.

The family Compositae is the largest of flowering plants: estimates of the number of species range from 13,000 to 20,000 – representatives are found throughout the world. The flowers are typically of the familiar 'daisy' form, but the family also includes such groups as the knapweeds and thistles, which at least superficially appear quite different.

Sunflowers support a large number of insects both living within the flower head and visiting for nectar and pollen – dissection results in a frantic scattering of a multitude of creatures. In comparison with the previous flower, the harebell, the sunflower is an insect zoo.

Paper: stretched Arches 90lb NOT. Image area: 340×180mm.

1. DRAWING [A]

Several flowers on longish stems were picked. One stem at a time was placed in 'oasis' to draw while the others were held in water.

Each flower is strictly a *capitulum* – an aggregate inflorescence of *ray*-*florets* and *disc-florets*, but for simplicity here I'll keep to 'flower' for individual heads.

The flower in 'oasis' was adjusted to be at eye-level and a rough projected layout was sketched in.

I first drew the disc (central) florets of the upper bloom. As this flower had been open for some time the discflorets were also well advanced. It was impossible to draw each minute element of the confused mass so I aimed for a general impression, taking care with the broad ellipse.

After drawing the central disc, the 'petals' (strictly the limbs of the rayflorets, and hereafter referred to as 'petals') were roughed in. With such regular flowers (cf. windflower, p. 34) you have to see that, in working your way around, you are not left with too little or too much space for the final petal. I began with the almost vertical petal at the top and then added others in turn to the left and the right – with adjustments here and there – until the whole head had been sketched in. Once the petal positions were established I lined them in and faintly indicated the main veins.

Next the stem was carried to the base of the plate showing the alternate leaves above and paired ones below. As usual, the midribs of the leaves were defined first, followed by generalized margins, the veins and finally the teeth.

I began the flower on the right with the *phyllaries* (bracts) below the petals. Then the petals on the left were roughed in, running behind the first flower, before the others were added keeping in mind the caution above. The whole head was then fined up.

The right flower-stem was carried to the base of the sheet together with leaves and side branchlets bearing buds. While drawing the stalk of the bud on the left I struck a difficulty

not met with before. It was an extremely hot day – a record temperature for Britain – and this caused either the eraser or the paper, or both interacting, to misbehave. In erasing, an ugly smear was left behind which I couldn't take off. You may see that there is a darkish smudge on the top left leaf of the first flower's stem. This happened when I tried to take out the initial line indicating the position of the bud-bearing stalk. To solve the problem I had to remove the already drawn leaf margin and then extend it over the mark - using the eraser very lightly while keeping its contact surface scrupulously clean. I also slightly diverted the bud-stalk to pass through the remainder of the blemish, hoping that colour would later hide it.

While continuing to draw I used the eraser as little as I could. Next came the left, opening flower, again starting with the phyllaries. The stem and leaves were drawn as before.

Last came the minute stiff hairs at the tops of the stems where they were more evident than elsewhere.

2. SHADING [B]

The shadow mix (p. 13) was used on the stems and leaves. This wash was further diluted for the petals – noting that changes of contour followed the veins. The remaining parts were detailed, including the central disc of the upper flower. Extra layers were dry-brushed where needed.

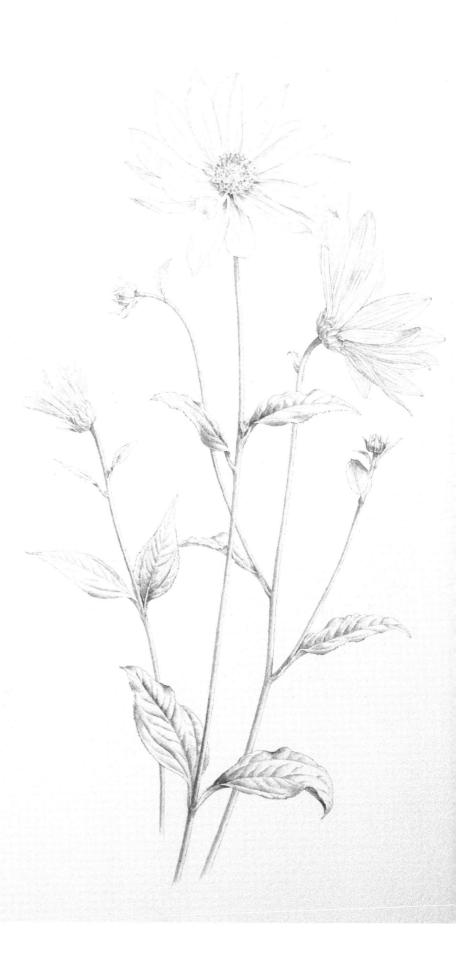

В

3. FIRST GREEN COAT; DETAIL OF FLORETS [C, D]

Pale yellow-green, derived from chrome yellow and Prussian blue, was first used for the central, unopened florets of the upper flower and then washed over all the vegetative parts. No highlights were left as the surfaces were matt.

After completing the wash I felt that it would be pleasing to add a detail of the florets, this would also better balance the composition. Accordingly, I used a scalpel to bisect a flower head and then with tweezers teased out a large ray-floret and tiny disc one. Both were drawn natural size and shading was added. For precision I preferred to use a needle-sharp 2H pencil rather than the darker F.

С

D

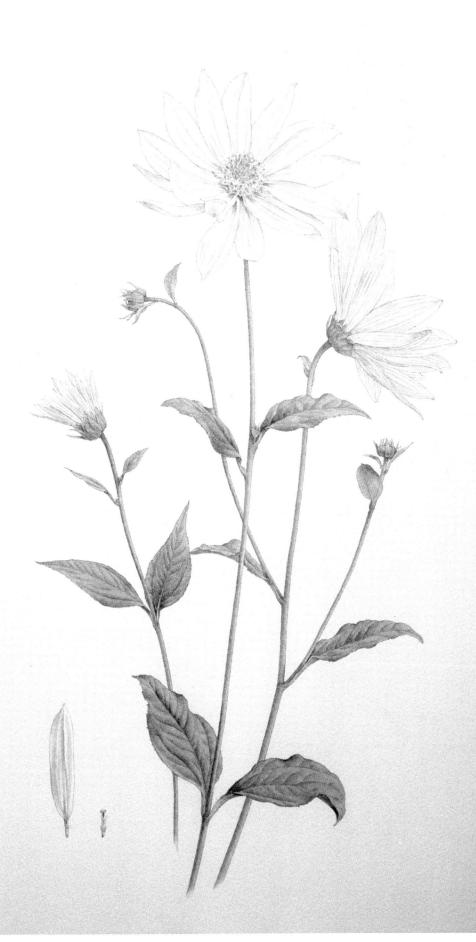

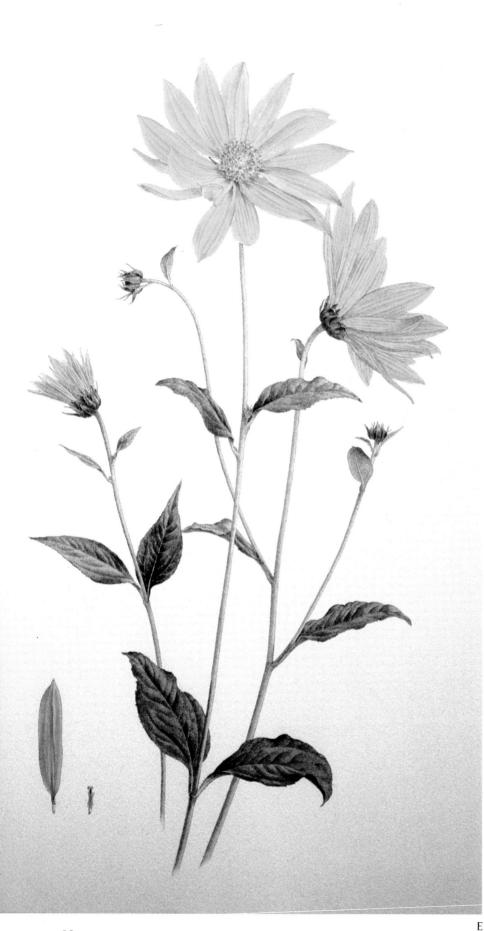

4. FIRST FLOWER COAT; SECOND GREEN COAT [E]

The bright colour of the petals came from a mixture of chrome yellow and lemon yellow. This was washed onto all of the floral parts with the exception of the green central disc.

The second green coat was made from chrome yellow and Prussian blue slightly modified by alizarin crimson – this was dry-brushed. I tried to leave extremely fine lines of the underlying green showing as veins. The phyllaries below the flowers and those enclosing the flower-buds were also painted.

5. SECOND FLOWER COAT; FINISHING TOUCHES [F, G, H, I]

A second coat of the petal yellow was dry-brushed where needed.

Next, the quite vivid stem colour was mixed from alizarin crimson and Prussian blue. I dry-brushed this on and added a second layer to the lower parts of the central and right stems.

French ultramarine, chrome yellow and alizarin crimson were the ingredients for the brown of the stamens encircling the stigmas – they show as dark marks on the central flower's disc as well as on the separate detail of the disc-floret.

The original stem green added emphasis to the upper areas while the shadow mix served the same function in the flower heads.

F. Sunflower, *Helianthus* cultivar, garden, August 1990.

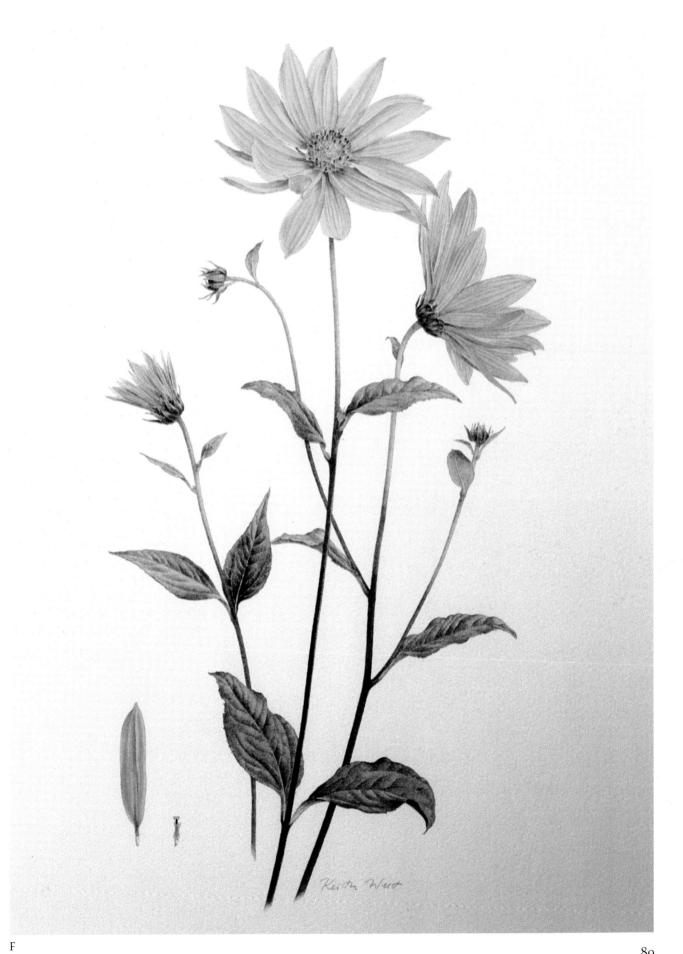

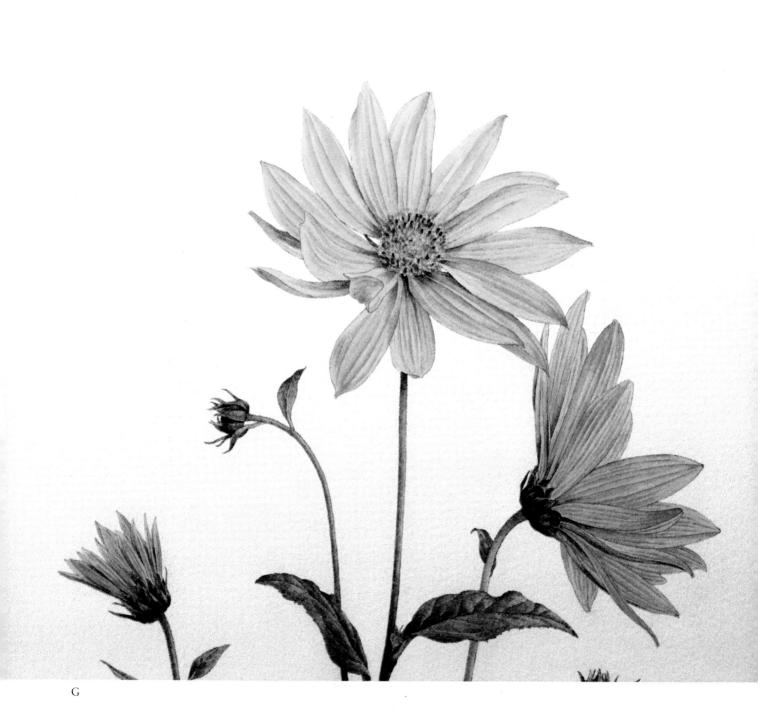

14 FUCHSIA cultivars: *Fuchsia* 'Billy Green'; *Fuchsia* 'Major Heaphy'; Family Onagraceae

For many years the charm of fuchsias passed me by. This now seems puzzling as I have gradually become an enthusiast – possibly due to having spent much of my life in New Zealand. There, the few native species include the most curious: the tree, *F. excorticata*, stout-trunked and reaching a height of 8 to 10 metres; and the sprawling *F. procumbens*, hugging the ground, showing erect, yellow-tubed, nectar-rich flowers. In the wild, this latter plant is restricted to a small coastal region – in cultivation it is seen around the world.

The genus comprises about 100 species, centred in South America. From a number of these, thousands of cultivars have been developed. This popular group has never acquired a common name other than the less than euphonious 'fuchsia'. This generic epithet honours a Bavarian physician, Leonhard Fuchs (1501–66). He wrote a modest text, *New Kreüterbuch* (based heavily upon Dioscorides) which is still admired for its refined woodcut illustrations.

Fuchsia flowers are pleasing to draw – their unique forms suggest oriental lanterns. Though I chose these two cultivars, you may prefer others to treat similarly.

Paper: stretched Arches 90 lb NOT. Image area: 300×220 mm.

1. DRAWING [A, B, C]

Both fuchsias were pot-grown so I had no need to detach material to arrange in 'oasis' etc. The only requirement was to clear enough space on a window ledge to accommodate them and to be able to move each backwards and forwards so that I could work on them in turn.

I started by indicating two main axes: one, for 'Billy Green', curved down from the top of the sheet towards the base; the second, for 'Major Heaphy', arched from right to left.

As I worked down from the apex of the 'Billy Green' stem I made small adjustments here and there better to reveal flowers etc. The drawing was taken to the large leaf on the right

towards the base of the stem – this leaf was only lightly sketched in as it might have had to be deleted to make way for parts of the 'Major Heaphy' branch.

Drawing of 'Major Heaphy' began with the apical buds on the left and I worked back towards the right. This was uncomfortable as I am lefthanded, but it was better than the awkwardness of trying to move from the right to the stem apex. The first, foreground, flower was damaged and this was replaced by substituting one of better form. I continued detailing along the branch to the margin on the right. Then it was possible to complete the lower stem of 'Billy Green'.

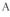

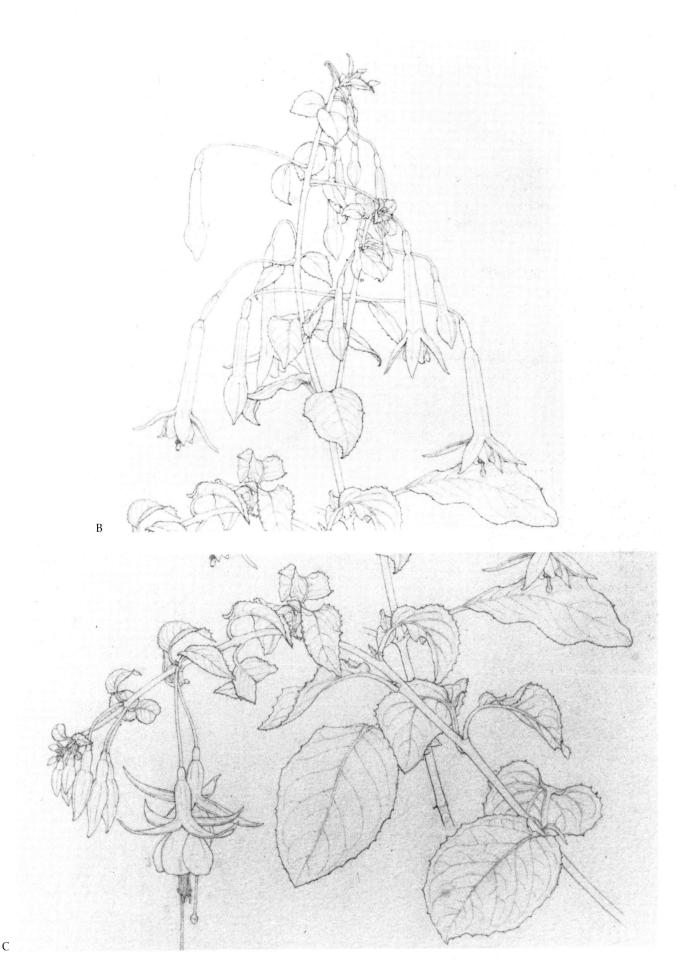

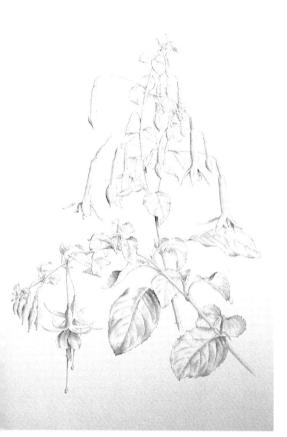

3. FIRST GREEN COATS [E]

Chrome yellow and Prussian blue were used for a pale yellow-green wash on the vegetative parts plus the ovaries and immature buds. 'Billy Green' came first – this plant had a matt surface without distinct highlights. 'Major Heaphy' had stems and leaves with a slightly shinier surface and so a few small clear areas were left.

The character of the green changed a

little towards the end of the 'Major Heaphy' branch. To show this a new mix was made of lemon yellow and Prussian blue. This brighter green appears on the apical leaves, the smaller flower-buds, parts of the maturing buds and also on the flower-stalks, ovaries and the tips of the sepals. The difference in hue is slight and may not show clearly in reproduction.

2. SHADING [D]

I used the shadow mix (p. 13) on 'Billy Green', pre-moistening floral tubes and leaves while progressing. The shading of 'Major Heaphy' followed in much the same way. After completing the first coat throughout, further tone was dry-brushed to deepen some shadows.

E

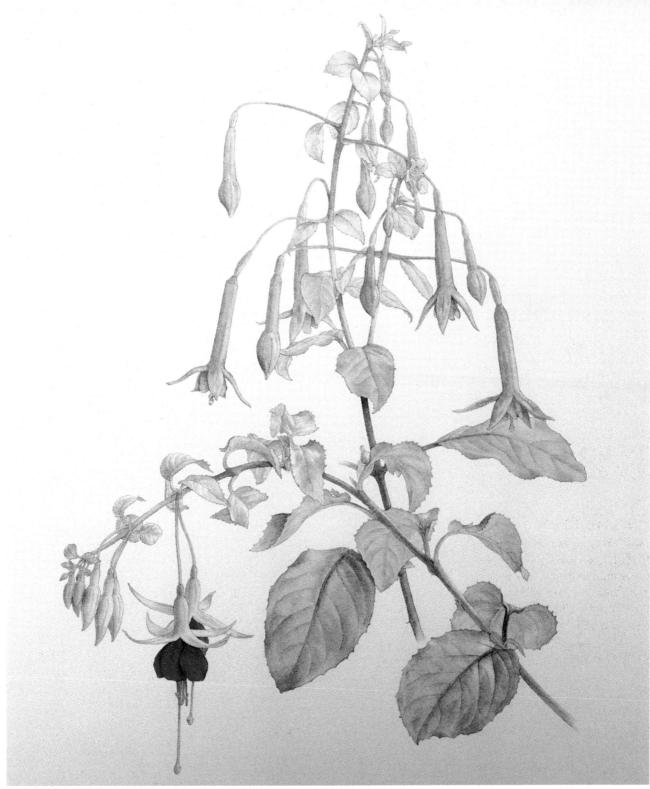

4. FIRST FLOWER COLOURS [F]

For the flowers of 'Billy Green', rose madder with some chrome yellow gave the underlying colour for both the outer and inner floral parts. The same colour was dry-brushed onto stems, *pedicels* (flower-stalks) and petioles, as well as the midribs of the leaves – so modifying the existing yellow-green to a reddish brown. 'Major Heaphy' flowers were fairly complex in their coloration. For the larger buds, and the calyces (the outer floral envelopes in fuchsias) a gold of chrome yellow with a brush-tip of rose madder was used – this also tinged the stigmas.

The rich red of the inner petals was composed of intense rose madder

with a stroke of chrome yellow. This red was also used for the stems etc. as for 'Billy Green'.

A very pale magenta warmed with rose madder served for the long styles carrying the stigmas. For the filaments of the stamens alizarin crimson was used alonc. To this colour chrome yellow was added for the anthers.

5. SECOND COAT FOR FLOWERS [G, H, I]

Rose madder with alizarin crimson supplied enrichment for the lower petals of the 'Billy Green' flowers.

For the 'Major Heaphy' blooms, Winsor red was used as a dilute wash on the upper parts of the calyces. The same hue was used in more intense form for the margins of the sepals and the corresponding lines on the larger buds. For the petals, the original colour, mentioned under step 4, was dry-brushed to bring them to full intensity. The upper parts of these petals were tinted with chrome yellow.

G

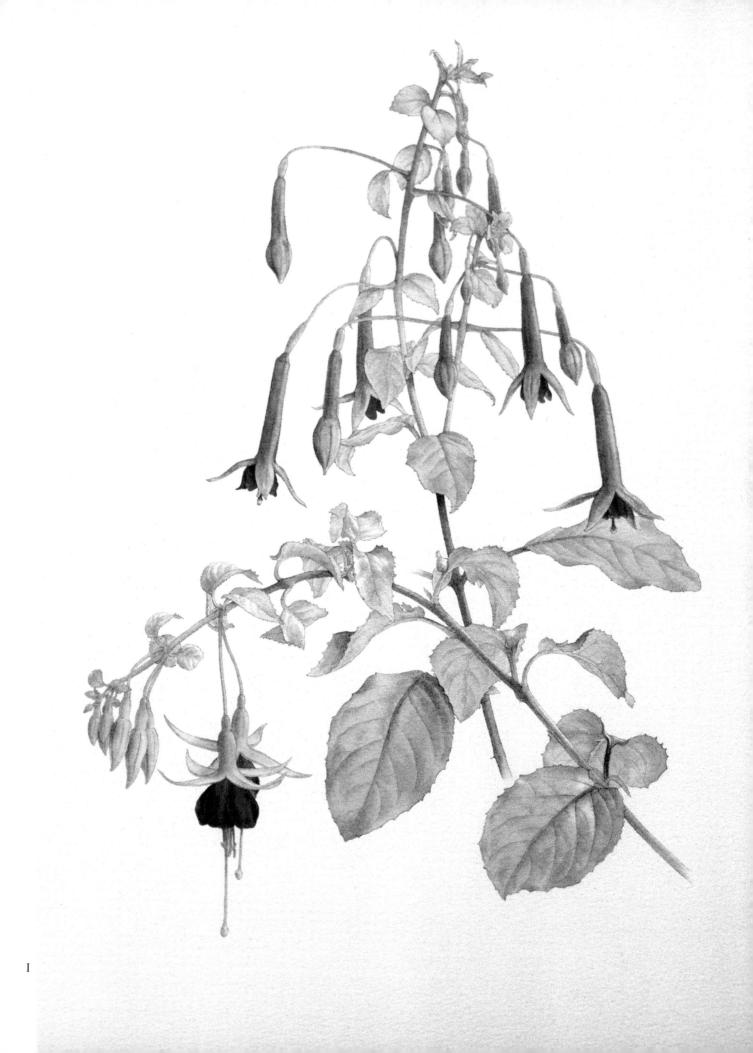

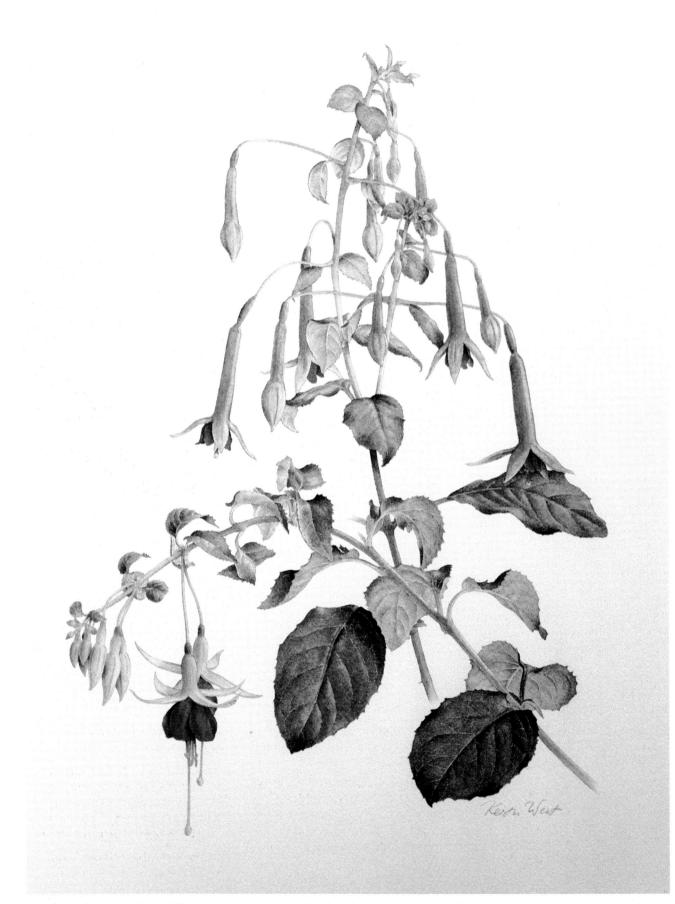

J. Fuchsia cultivars: Fuchsia 'Billy Green'; Fuchsia 'Major Heaphy', garden, August 1990 (flowering continues into early autumn).

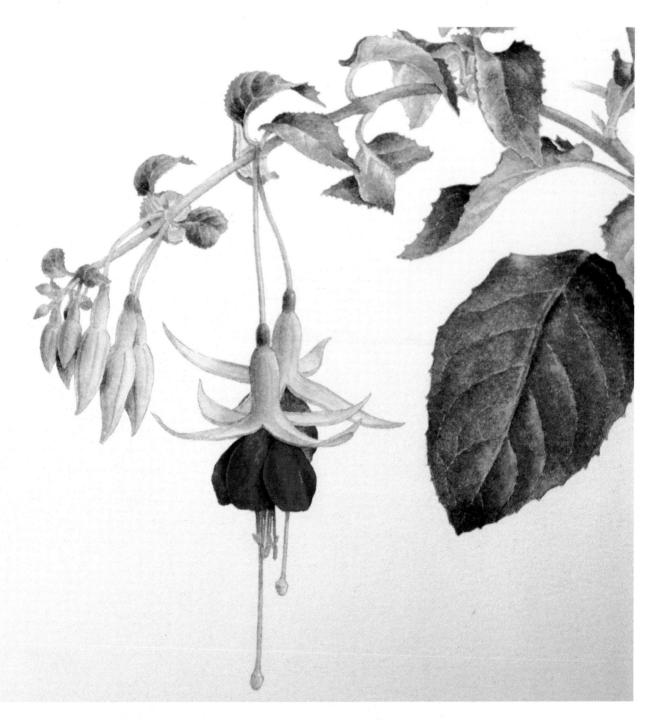

6. SECOND GREEN COATS; FINISHING TOUCHES [J, K, L, M]

Initially, I tried to reach the final colour of the 'Billy Green' leaves through a mix of lemon yellow and Prussian blue. This was too vivid and so minute amounts of chrome yellow and alizarin crimson were added. This was dry-brushed leaving line breaks for venation. The undersides of the leaves were a little lighter and some moist pigment was lifted off to show this. Excess pigment was also blotted from the upper surfaces of the

Κ

leaves in lighter areas – mainly adjacent to veins. The ovaries were similarly coloured.

The green of 'Major Heaphy' differed from that of the other fuchsia in having more blue in its composition though the difference was not marked. I made a new mixture by taking part of the 'Billy Green' wash and adding extra Prussian blue (keeping back some of the original wash for later adjustments). This new wash was applied to the leaves and ovaries.

I then returned to 'Billy Green' to dry-brush some of the original mix into the darker areas of the leaves before doing the same with 'Major Heaphy' using the later wash colour.

The buds of 'Major Heaphy' were touched with chrome yellow.

Finally, the shadow mix was used to heighten contrasts.

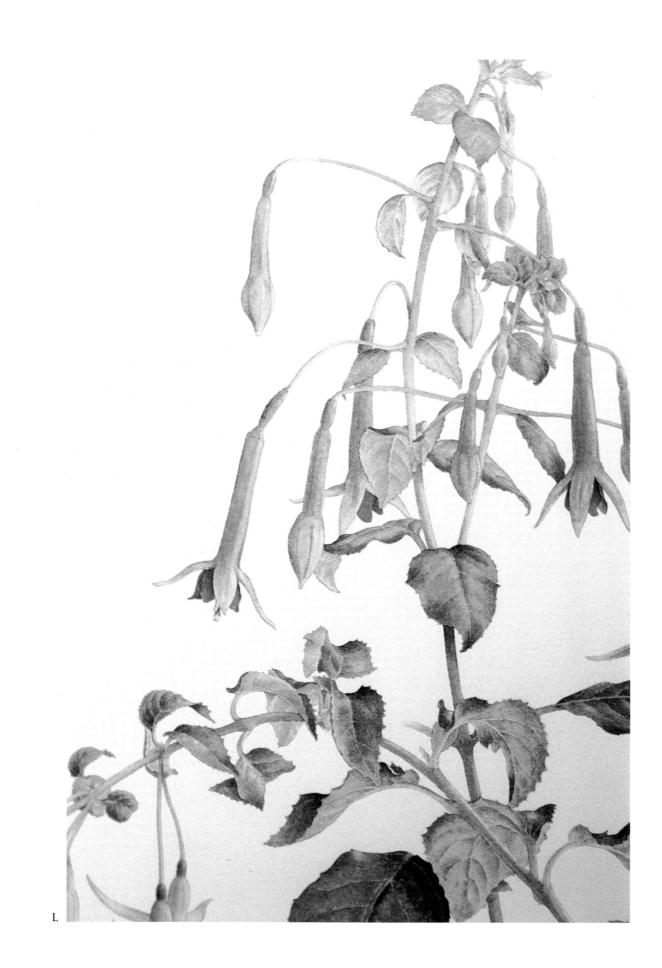

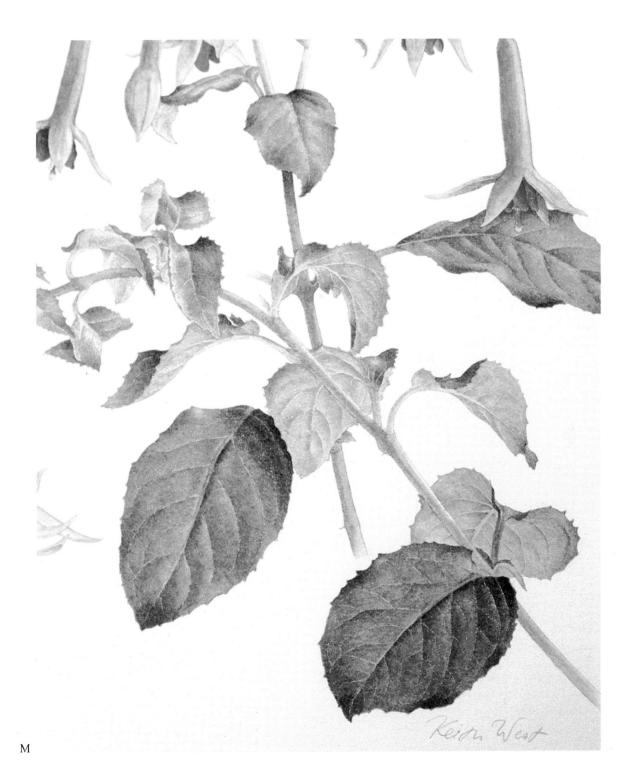

15 PERUVIAN LILY, Alstroemeria 'Sovereign'; Family Alstroemeriaceae

There are some sixty species in the genus *Al-stroemeria*. Most of the few in cultivation are not listed as coming from Peru, as might have been expected from their common name, but rather from Chile – niggling for the Chileans.

I chose this plant because I wanted to finish with something widely grown, not too complex, yet especially eye-catching. If you have time the portrayal on one plate of several of the forms available would make a spectacular painting. I was tempted to do this but felt that the less experienced might be deterred by the extra effort needed.

The dark markings of the inner perianthsegments are probably nectar guides as the twin upper segments carry copious nectar in their tubular bases.

Paper: stretched Arches 90lb NOT. Image area: 330×165 mm.

1. DRAWING [A, B]

I began by showing the position of the main flowering stem and one to carry buds on the left. Space on the right was reserved for a developing capsule.

The flowers were irregular, consisting of three outer segments, pale and delicately marked; and three inner segments of a rich yellow bearing dark stripes.

I roughed in the upper, striped, segments of the centre flower, then before fining them up I drew the stamens and style and sketched in the outlines of the other segments. The minutely toothed segments' margins were detailed. The stripes of the inner segments were left till later.

The flower on the left was then positioned – roughing in the petals before drawing the sexual parts and fining up.

After the two foreground flowers had been drawn I established the pair of flowers to the rear.

Next came the stem of the first flower down to and including the branchlet with buds, followed by the bloom on the left. The two flower-stalks were next carried down to their junction with the two rear flower-stems and these were also put in – after finishing the three leaves at the head of the main stem.

On completing the above steps it seemed appropriate to go back to the flowers to figure the dark markings on the perianth-segments.

The main stem and leaves followed, noting that the venation of the upper surface of the leaves was clearer than that beneath.

At this point I could see that the intention to use three elements in the

painting would no longer be sensible – the completed stem filled more space than anticipated. The plate would now be of a single stem plus a detail of a developing capsule.

The curious capsule with its stalk and bract was placed on the right and turned so that four of the six keeled edges of the swelling vessel could be seen.

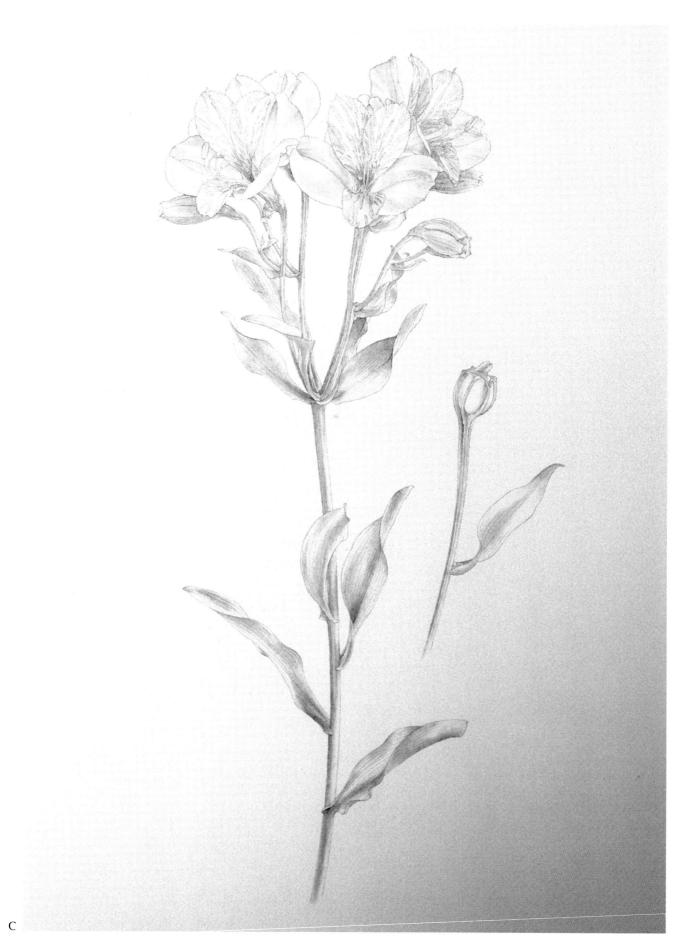

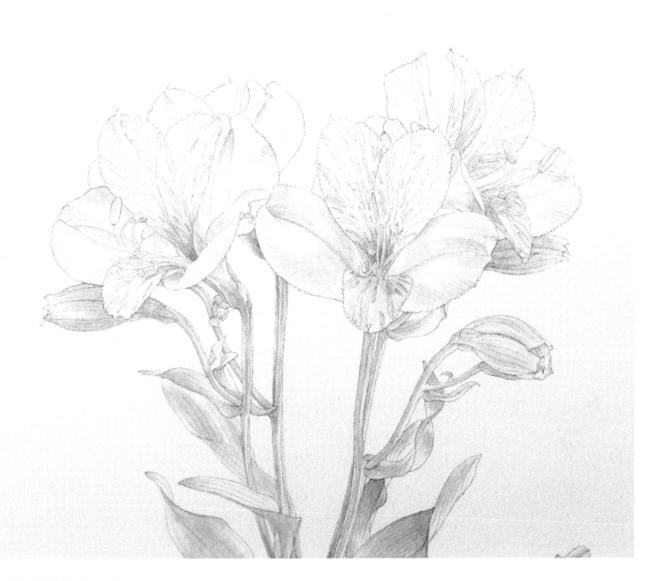

2. SHADING [C, D]

The shadow mix (p. 13) was used for the capsule detail. Then the main stem was worked on starting with the vegetative parts at the top and leaving the flowers until last. While shading the flowers I tried to show some of the fine fluting on the surface of the perianth-segments.

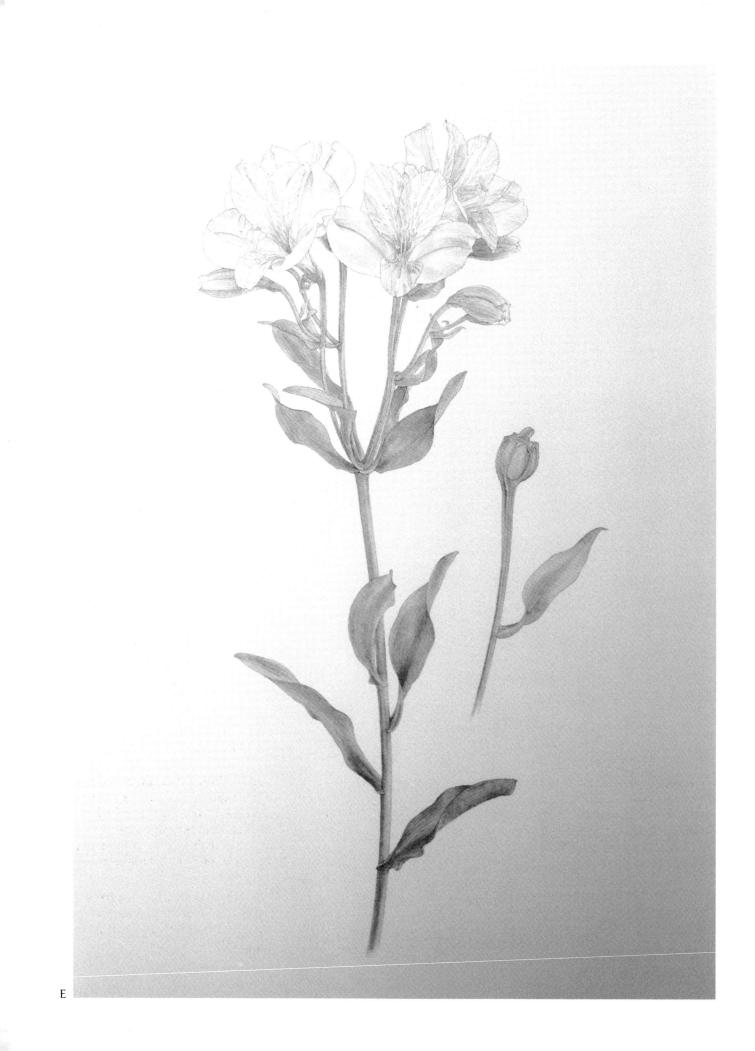

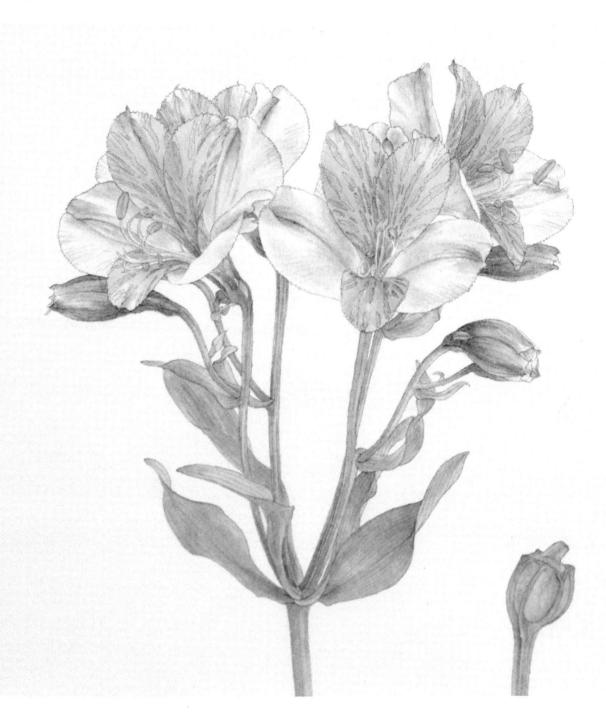

3. FIRST GREEN COATS [E]

Most of the vegetative parts were blue-green, except for some translucent portions, the venation, and parts of the buds and capsules which were yellow-green. I gave a first underlying coat throughout of this yellowgreen mixed from lemon yellow, some chrome yellow, and Prussian blue. On completion I felt that the translucent areas needed to be brighter and these were enriched by adding more chrome yellow to the wash.

4. FIRST FLOWER COATS [F]

A soft glow of chrome yellow was dry-brushed onto the central parts of the outer perianth-segments and touches of the same colour were given to the buds.

For the inner segments I added more pigment to the chrome-yellow wash to reflect their depth of colour. Where the twin upper segments overlapped, the yellow was especially rich and to reach this I added Winsor red to the mix. Pinkish blushes about the central tips of the segments and on the buds were created from rose madder and a dab of Prussian blue. Touches also appeared on the capsule, the leaf tips, and on lower parts of the flowerstalks.

The anthers were an unusual greenish yellow mixed from lemon and chrome yellows with a drop of French ultramarine. 5. SECOND GREEN COAT [G]

To capture the blue component in the greens I mixed dilute Prussian blue with chrome yellow and lemon yellow. This was washed on throughout but for translucent areas.

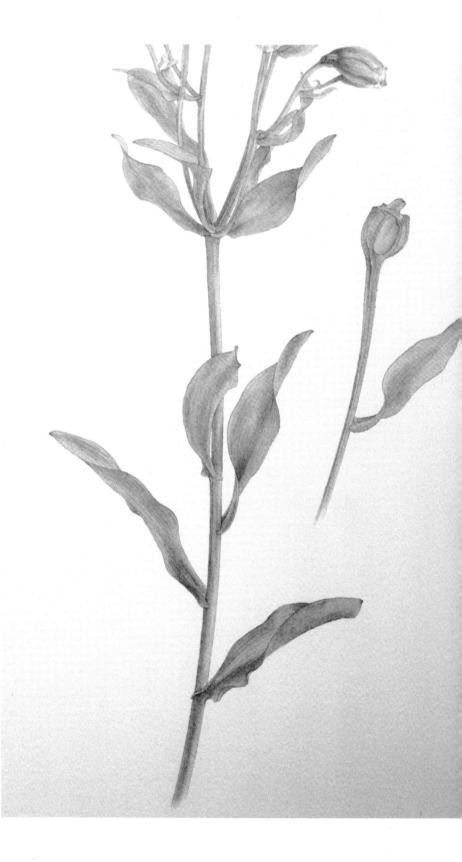

G

6. FINAL GREEN COAT [H]

The finishing green of translucent patches was rich and bright – this was mixed from chrome yellow, lemon yellow, and Prussian blue – the same ingredients as above but with a greater yellow component. To reveal the parallel venation the colour was drybrushed on in lines; several coats were used in places. Further brightness was added to some of the lighter parts of the leaves by dry-brushing in a mix of chrome and lemon yellows.

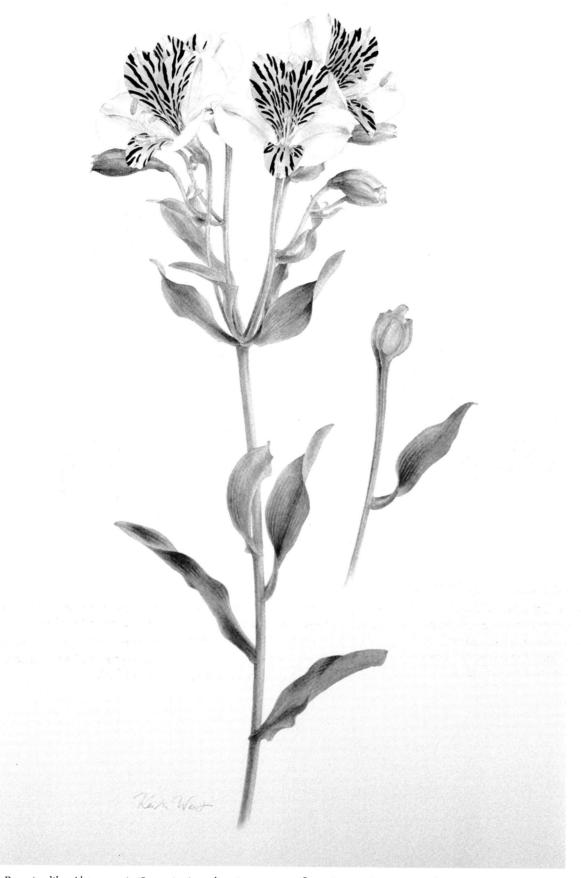

I. Peruvian lily, Alstroemeria 'Sovereign', garden, August 1990 (flowering continues into early autumn).

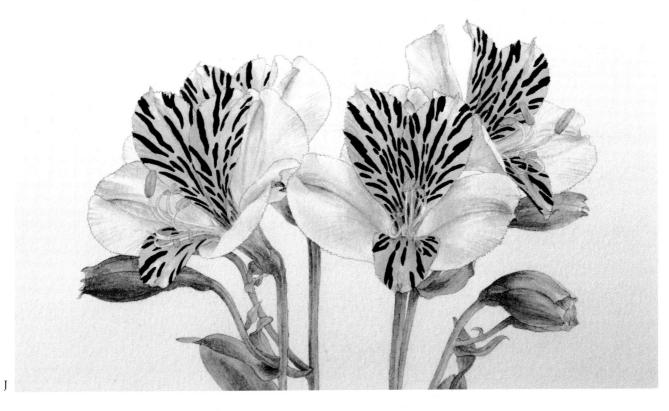

7. FINISHING TOUCHES [I, J]

The dark slashes on the inner perianth-segments came from alizarin crimson, French ultramarine and a hint of chrome yellow. Markings were in the main sharp-edged, though a few about the bases of the inner segments were blurred. The mix was dry-brushed with two coats being needed in places.

To help balance the strong contrasty

segments I used more of the shadow mix in the darker places.

The pink of the segment blushes was used again as a final tinting of the flower-buds.

Index

Alstromeriaceae 102 Alstromeria 'Sovereign' 102-11 Amaryllidaceae 19, 28 Anemone blanda 34-41 A. coronaria 34 A. x hybrida (syn. A. japonica) 34 A. nemorosa 34 basic watercolour techniques 14-17 blended edges 16 corrections 16, 17 dry-brush 14, 16 gradated wash 14, 16 highlights 16 wash 14 Bauer, Ferdinand 7 Bauer, Franz 7 Bellini, Jacopo 42 botanical knowledge 8 brushes 12 Campanulaceae 78 Campanula rotundifolia 78-81 Candlemas bells 19 Caryophyllaceae 50 chiaroscuro 13

chiaroscuro 13 cockling 12, 13 colour reference chart 17 Compositae (Asteraceae) 84 craft knife 11 daffodil 28–33 *Dianthus* cultivar 50–5

Dioscorides 92 dividers 11 drawing 13 leaves 13 skeleton framework 13–18 regular flowers 34, 84 drawing board 11 lightweight 12 drawing stand 11 Dürer, Albrecht 42 Dutch painters 42

Ehret, Georg 7 eraser 12 problem with 84 Eschscholtzia californica 56

feather 11 February fair maids 19 Flemish painters 42 florists' 'oasis' 12, 18 Fuchsia cultivars – 'Billy Green', 'Major Heaphy' 92–101 F. excorticata 92 F. procumbens 92 Fuchs, Leonhard 92

Galanthus nivalis 19–27 Garden of Roses, A 70 gouache (body-colour) 8 gummed brown-paper strip 12, 13, 14

hand-lens 11 harebell (bluebell) 78–81 *Helianthus* cultivar 84–9 Herbals 7 *How to Draw Plants: the techniques of botanical illustration* 8

Iridaceae 42 iris 42–9 *Iris sibirica* cultivar 42–9

Lathyrus odoratus cultivar 64–9 Leguminosae 64 Leonardo da Vinci 42 Les Roses 70 lighting 11 line drawings 7

Meconopsis betonicifolia 56 M. cambrica 56 M. grandis 56

Narcissus bulbocodium 28 N. cultivar 28–33 N. cyclamineus 28 New Kreüterbuch 92

Onagraceae 92

pale flowers, treatment of 54 palettes 12 Papaveraceae 56 Papaver alpinum 56 P. nudicaule 56 P. rhoeas 56–63 paper 12 (brand, type and weight are also given under each plant subject in the text) protective sheet 14 use of back of sheet 18 paper towelling 12 Parsons, Alfred 70 pencils 12 perspective 13 Peruvian lily 102–11 pink 50–5 plant containers 12 poppy, alpine 56 California 56 field 56–63 Himalayan 56 Iceland 56 Shirley' 56 Welsh 56

rag 12 Ranunculaceae 34 Ranunculus ficaria 34 Redouté, Pierre-Joseph 7, 70 Romneya 56 Rosaceae 70 Rosa 'Super Star' 70–7 rose 70–7 Rubáiyát of Omar Khayyám 70 ruler 11 Ruskin, John 56

scalpel 11 seat 11 shading 13 shadow colour 11 shadow mix 13 snowdrop 19–27 speed of working 7 stretching 13 subjective line 20 sunflower 84–9 sweet pea 64–9

translucence 18

van Gogh, Vincent 42

watercolour paints 11 board 12 compatibility 12 core colours 11 opaque pigments 8 pans 11 tubes 11 water-jar 12 white flowers, treatment of 19 windflower 34–41 work space 11 working surface 11